Marie 7

MEMPHIS

BARBARA RADICE

**RESEARCH, EXPERIENCES,
RESULTS, FAILURES AND SUCCESSES
OF NEW DESIGN**

THAMES AND HUDSON

Invitation to the first Memphis exhibition, 18 September 1981,
Milan, Arc '74 Showroom.
Designed by Luciano Paccagnella.

For Ettore Sottsass and the Memphis architects and designers

Translated from the Italian
by Paul Blanchard

Any copy of this book issued by the publisher as a
paperback is sold subject to the condition that it shall
not by way of trade or otherwise be lent, re-sold, hired
out or otherwise circulated, without the publisher's prior
consent, in any form of binding or cover other than that
in which it is published and without a similar condition
including these words being imposed on a subsequent
purchaser.

First published in Great Britain in 1985
by Thames and Hudson Ltd, London
Reprinted 1985

© 1984 by Gruppo Editoriale Electa, Milan

All rights reserved. No part of this publication may be
reproduced or transmitted in any form or by any means,
electronic or mechanical, including photocopy,
recording, or any information storage and retrieval
system, without permission in writing from the publisher.

Printed and bound in Italy

Ettore Sottsass, "Bacterio" drawing
for HPL Print laminate, 1978.

The Nursebot
"Zack pressed the red dot on his metal palm, got a
reading off the tiny digital screen that
winked absolutely correct time at him. 'Shit, nearly
midnight', he said aloud.
The room was twelve feet square, too full of furniture
and color. There were three pastel-tinted lucite sling
chairs, a crimson slumpcouch, a yellow plastic hammock
bed, five green end tables and a watchful chromed
nursebot standing straight and silent in the far corner."
Ron Goulart, *Upside Downside*

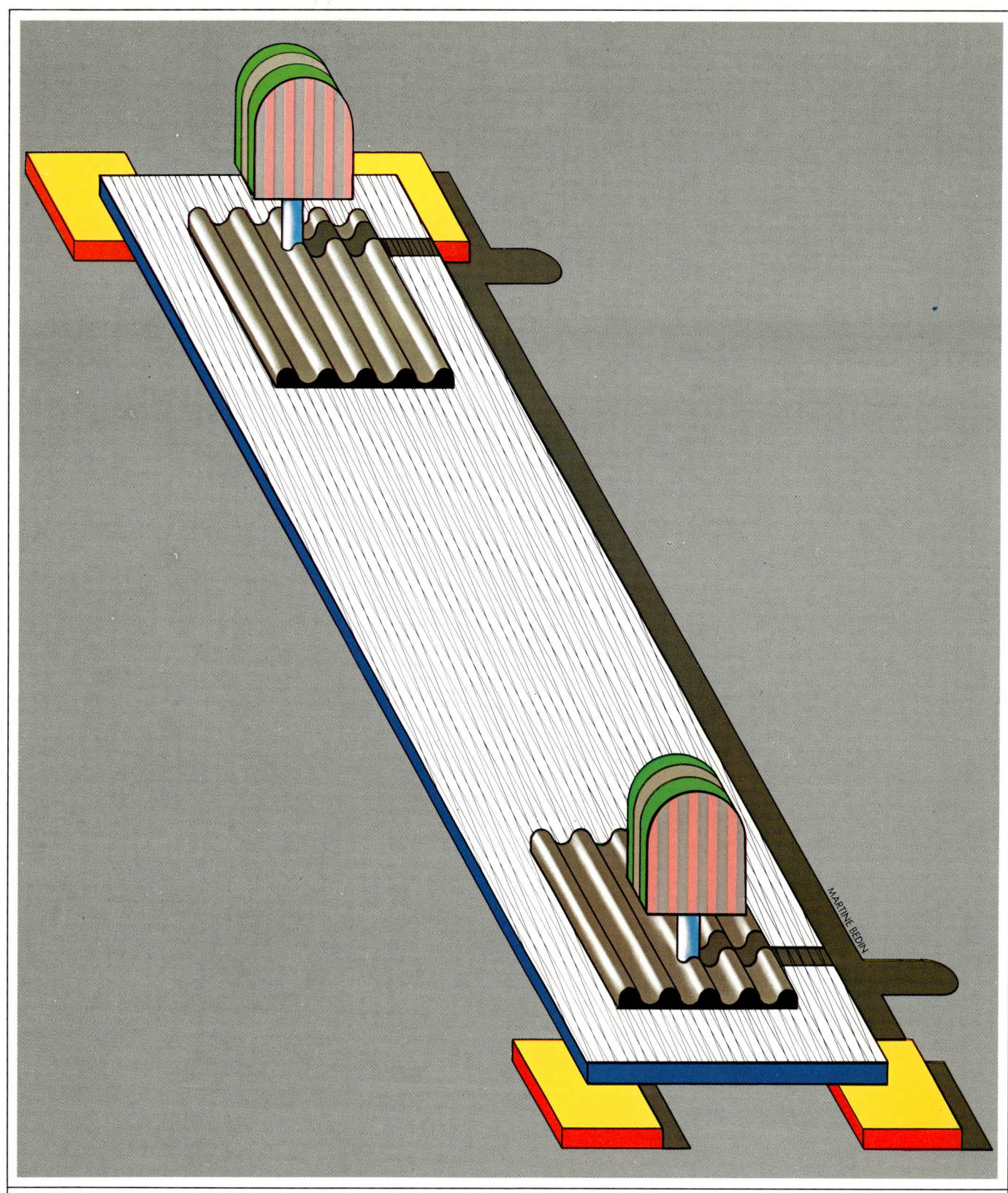

Martine Bedin, Memphis poster 1981.

This book would not have been possible without the help and cooperation of the photographers, magazines, and publishers who have generously granted rights to reproduce the photographs published here.
I am particularly grateful to my friends at Studio Azzurro, to Aldo and Marirosa Ballo and to Isa Vercelloni, for their kind and continuous cooperation and friendship through three years of work with Memphis. I also wish to thank the photographers Santi Caleca, Roberto Carra, Guido Cegani, Centrokappa, Mitumasa Fujiuka, Jan Jacobi, Giorgio Molinari, Occhio Magico, Peter Ogilvie, Pino Prina, Pino Varchetta, Fabio Zonta; the painter Luciano Paccagnella for the illustration of the tyrannosaurus; *Casa Vogue*, *Donna* and *First* magazines. Thanks finally to Abet Print and to Guido Jannon for their continuous assistance and for their research and cooperation with Memphis.

CONTENTS

INTRODUCTION
by Ettore Sottsass
11

MEMPHIS
23

PLASTIC LAMINATE
35

MATERIALS
67

DECORATION
87

COLOR
121

THE MEMPHIS IDEA
141

THE DESIGN
173

MEMPHIS AND FASHION
185

INDICES
206

Invitation to the second Memphis exhibition, 19 September 1982,
Milan, Arc '74 Showroom.

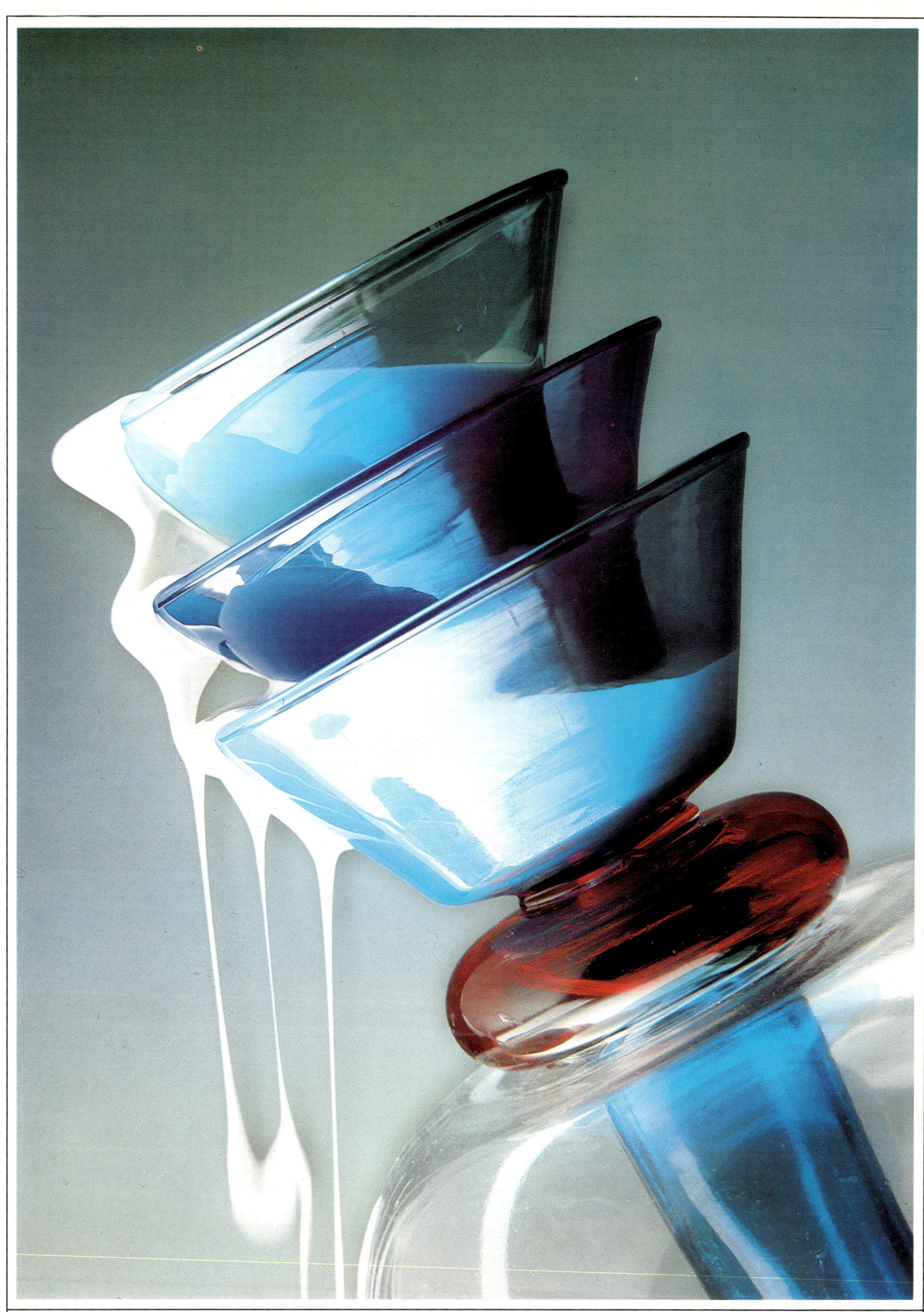

Marco Zanini, "Alpha Centauri," Memphis 1982. Blown glass.
Produced by Toso Vetri d'Arte, Murano.

INTRODUCTION

And now there's also a book, a nice, big book.
The young, calm photographers have taken their precious pictures, Barbara Radice has provoked the decisions and written the text, Nathalie du Pasquier has designed the cover, Christoph Radl and the Publisher's art directors have pasted it up, the Publisher has printed, folded, and bound the pages and now everybody's happy. This nice, big book exists and will go out into the world, and students may not be able to buy it because it'll cost a lot, but they'll find it somewhere and they'll be able to look at it somehow, and those who can afford it will put it on the table and it'll stay there for a while. And for a while here and there on the planet people will talk about the book, and then the book will go onto the shelves of elegant bookcases, between the *History of Art Nouveau* and *Japanese Packaging* perhaps, or between *Jugendstil* and a book by Charles Jencks. Where it will end up nobody knows. Everybody will bury it where they want, so good-bye book and good-bye Memphis, both destined for another life, committed to a journey on the boat of the Sektet, in some remote corner of space that lies toward the evening darkness.
Now, with this book, those who are here on the morning side, on the side of the Matet– I'm talking about those who did these things later called Memphis and who can never stand still because they stand up straight on their two feet – will end up looking at themselves in a different light. They'll be thrown off balance for a while, they'll have to step back, so to speak, and take other measures. No doubt they'll have to step on the gas, speed up, and produce more energy. For now the old state of things – the state of discovery, surprise, haste, and even anxiety, the state of presumption and arrogance, of certainties and cosmic uncertainties – alas, that shining old state of things, is gone. It has taken its boat laden with flowers, fruit, vegetables, flying ducks and baskets of fish and it's gone off along rivers, canals, and marshes that no one even knows about, or ever will know...
But this is nothing to worry about. This is an old, a very old story, and the plan certainly is not to give way to nostalgia, or still less to the usual, macabre laments over the thousand golden ages that every tomb conceals. If there is a plan, it is to defy this old story, to gaze calmly at the murderous black holes that emerge when we confront the sulphuric acid of time, and to avoid them, to slip between them and to abandon in cosmic space, time and time again, everything that seems achieved, certain, perhaps true or real or even just reasonable – including what has been deposited in a book – and then to imagine everything that has been deposited in this book as an accident, just one among any of the possible accidents, one among any of the possible quasi-solutions available; indeed, to imagine the Solution, the Solutions, as nothing other than conscious travel notes, conscious momentary and provisional figures that can be envisaged during the great, mad, supersenseless journey of History. There's nothing else for the time being.
But there's a rendezvous.
Those who in 1981 designed the idea now called Memphis are almost all very young. No doubt one fine day, one fine sudden day, they will put together another book. It will be the book that everybody has been waiting for in order to survive, and it may not even be called Memphis.

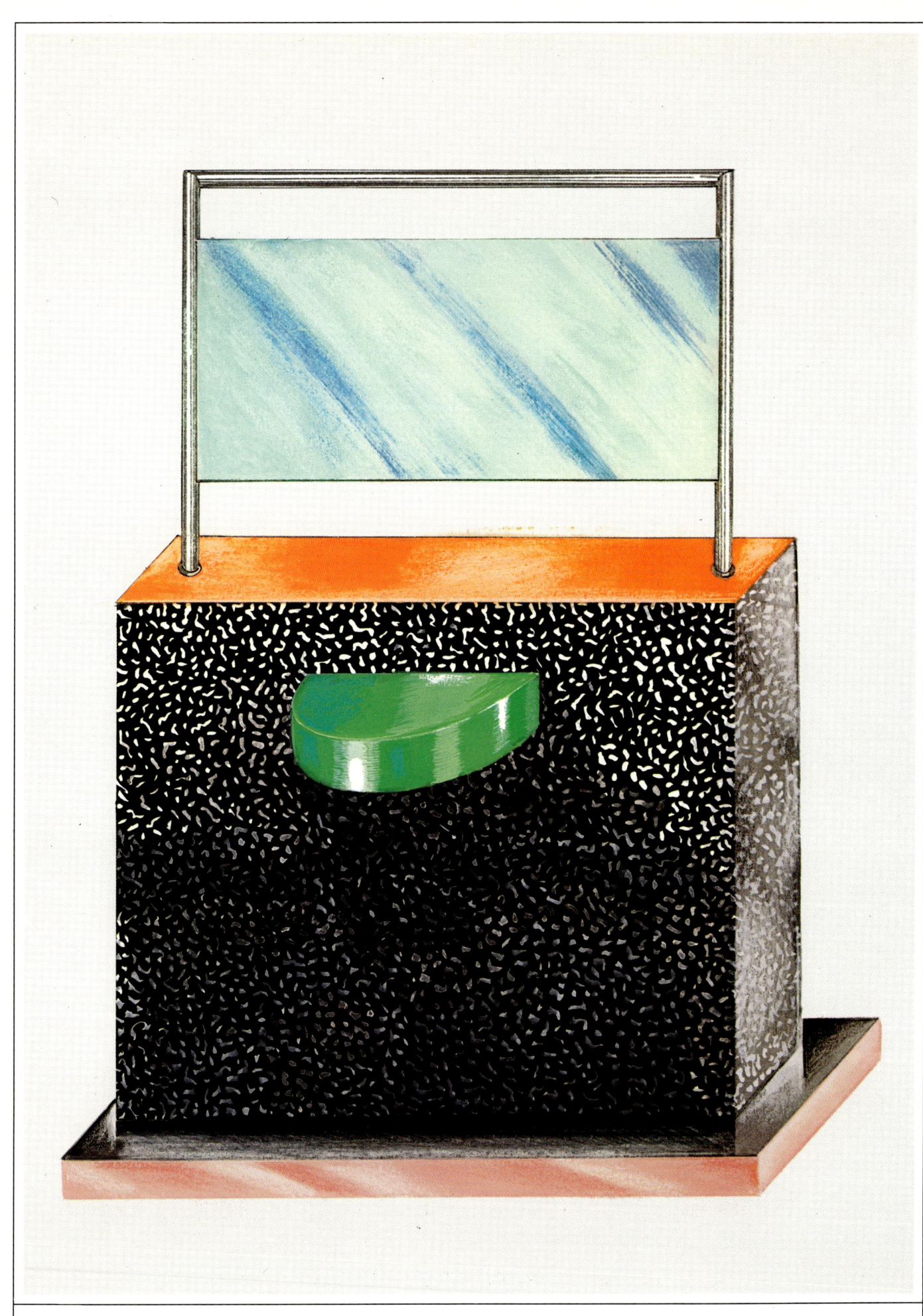

Ettore Sottsass, design for a piece of hall furniture, 1979.

Ettore Sottsass, "Capodanno" lamp, Alchymia 1979.
Plastic laminate and brass.

Ettore Sottsass, "Cioccolato" centerpiece, Alchymia 1979.
Lacquered wood and celluloid.

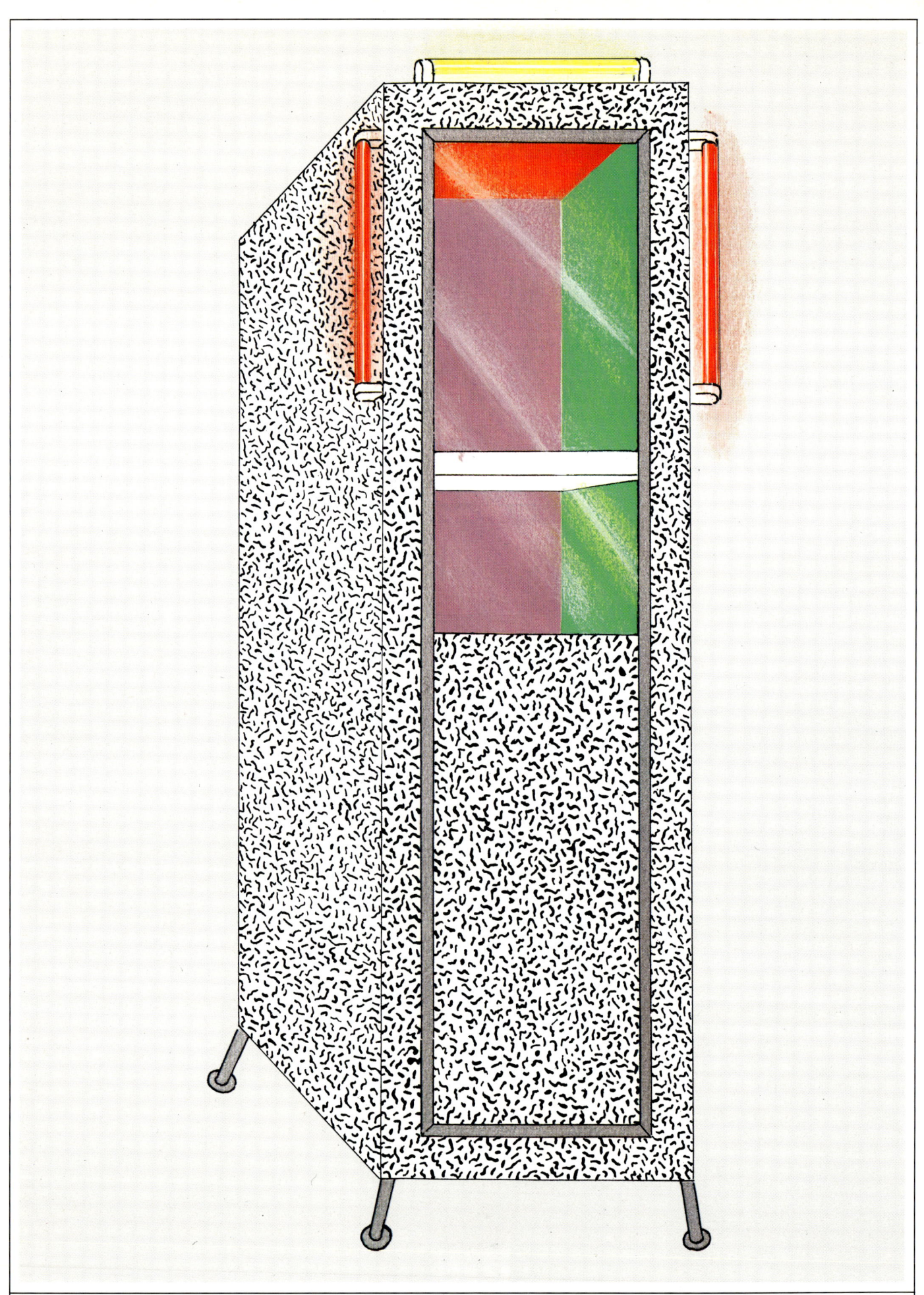

Ettore Sottsass, design for "Vetrinetta di Famiglia," 1979.

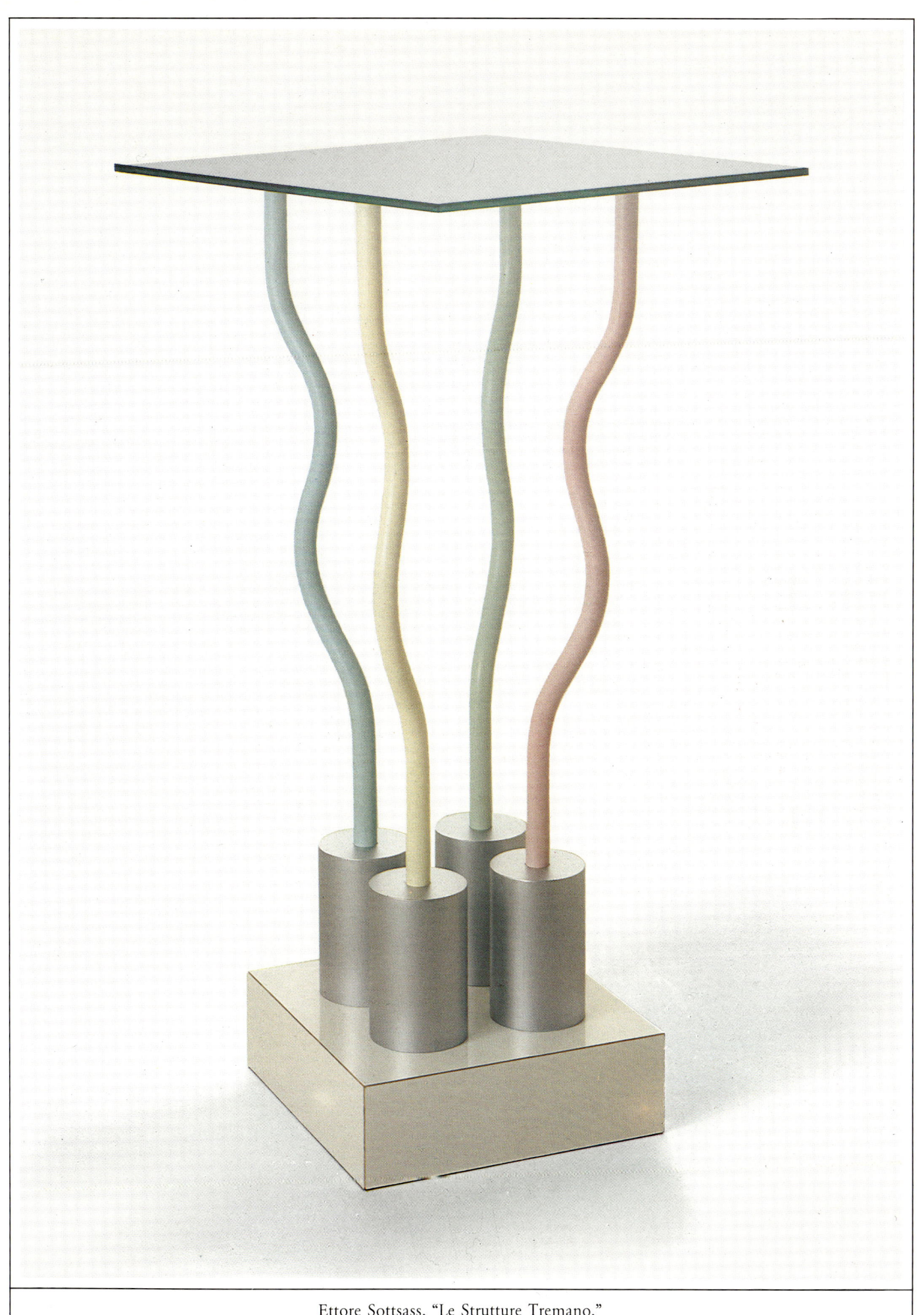

Ettore Sottsass, "Le Strutture Tremano,"
Alchymia 1979. HPL Print laminate, metal
and plate glass.

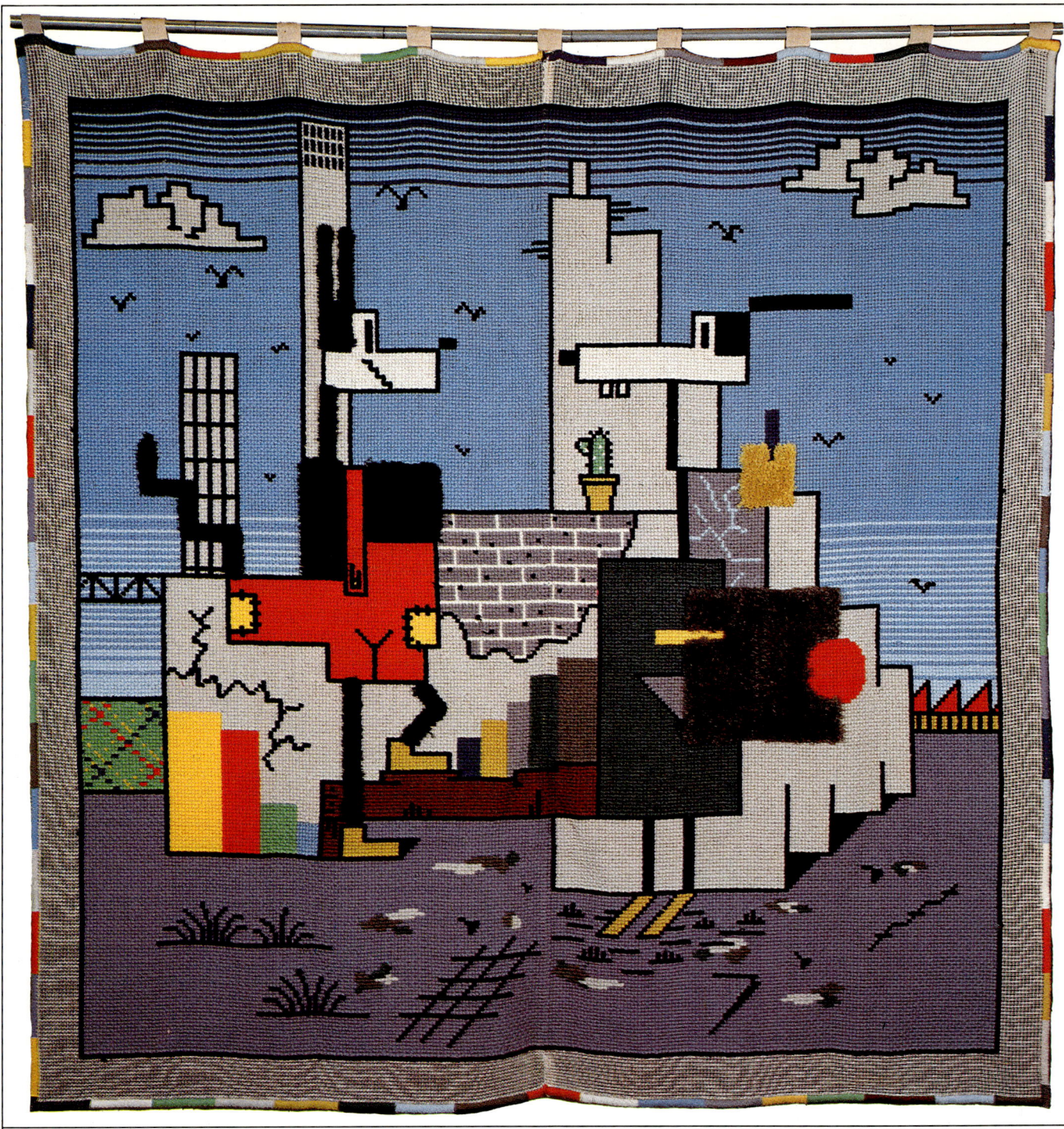

Andrea Branzi, "Coppia Metropolitana," 1978.
Hand-embroidered tapestry.

The Tranquil Room

"There were two doors, an outer and an inner, with clothes-hooks in the space between. Joachim had turned on the ceiling light, and in its vibrating brilliance the room looked restful and serene, with practical white furniture, white washable walls, clean linoleum, and white linen curtains gaily embroidered in modern taste. The door stood open; one saw the lights of the alley and heard distant dance-music. The good Joachim had put a vase of flowers on the chest of drawers – a few bluebells and some yarrow, which he had found himself among the second crop of grass on the slopes."
Thomas Mann, *The Magic Mountain*

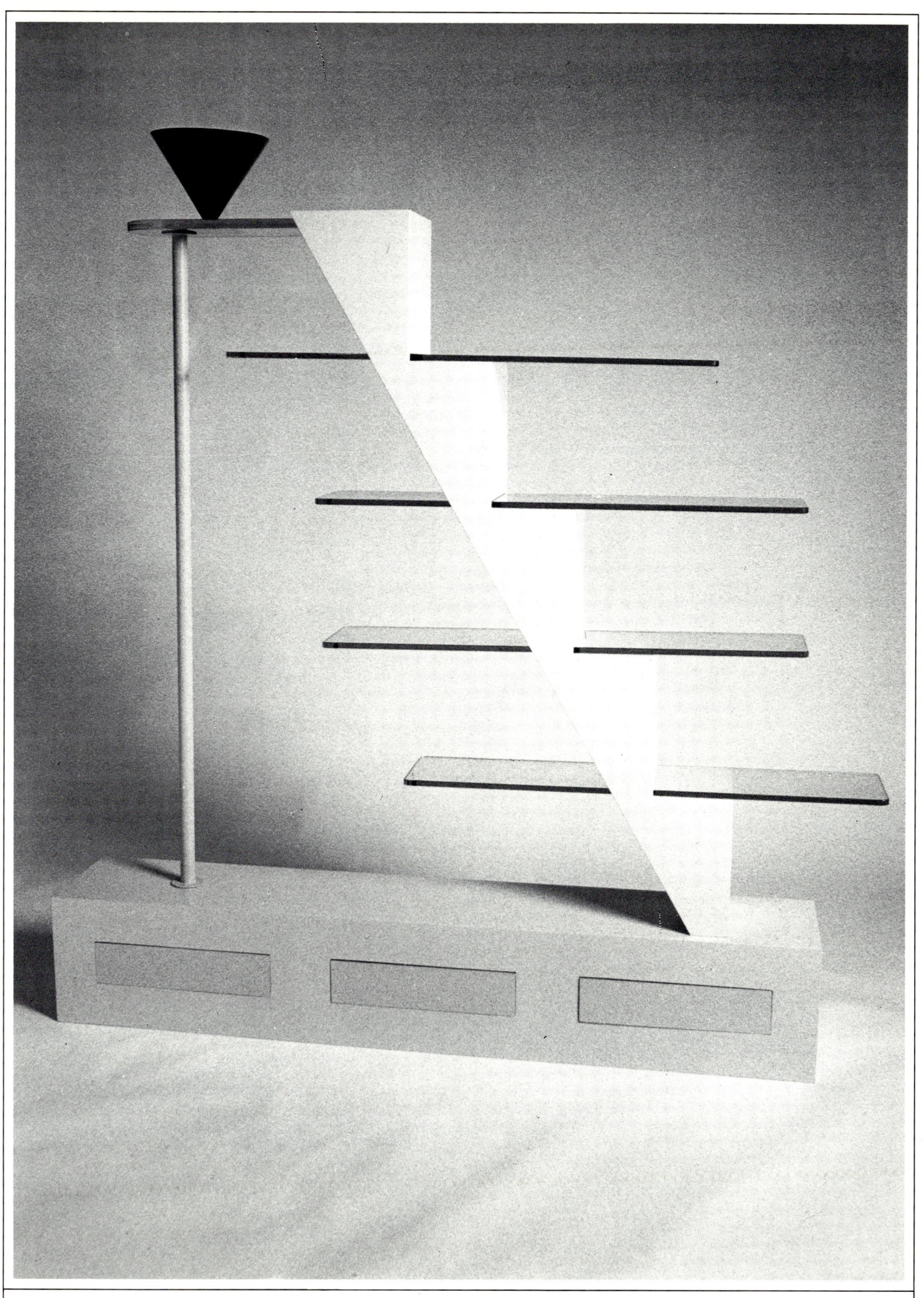

Andrea Branzi, "Libera" bookcase, Alchymia
1980. Lacquered wood, HPL Reli-tech Print
laminate and plate glass.

Andrea Branzi, "Centrale" table, Alchymia
1979. Metal and plate glass.

Andrea Branzi, "Stazione," Alchymia 1979.
Lacquered wood, metal and plate glass.

Andrea Branzi, "Muzio," Alchymia 1979.
Lacquered wood, metal and plate glass.

Michele De Lucchi, drawings for lamps, 1979.

Michele De Lucchi, drawings for Hi-Fi, 1980.

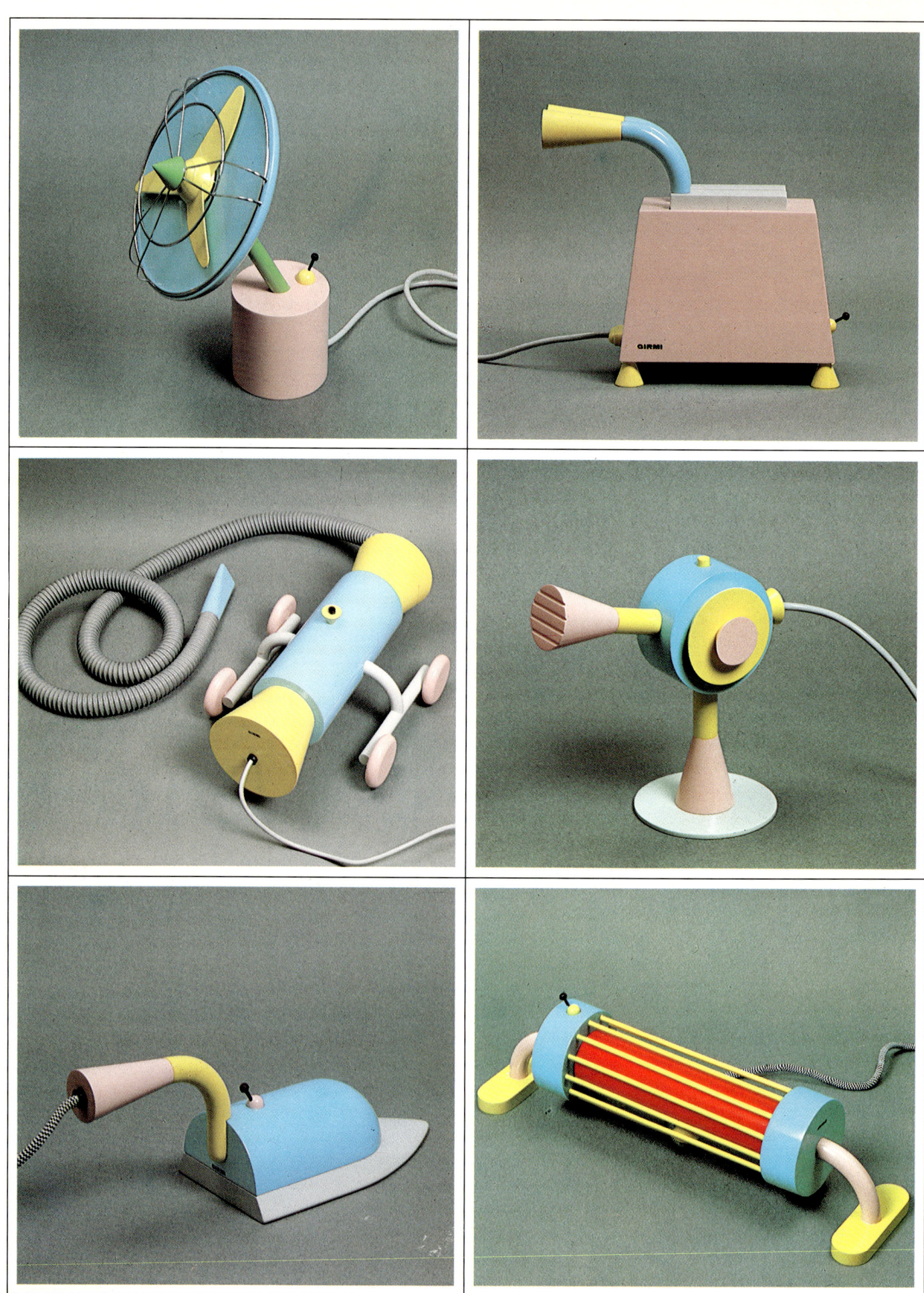

Michele De Lucchi, "Appliances," lacquered wood prototypes produced for the Triennale di Milano, 1979.

MEMPHIS

Memphis was born in the winter of 1980-81 when a group of Milanese architects and designers felt an urgent need to reinvent an approach to design, to plan other spaces, to foresee other environments, to imagine other lives.

This need did not happen at once. The designers had been working on projects and ideas for two or three years. To succeed in giving them a physical form, to see them realized, had become almost a question of life or death, an obsession that coincided with their own creative capacity.

This need also involved the contagious, almost reckless desire to strike a blow against current circumstances, as well as against the weary "good taste" and expressive poverty that continued to drag along in houses furnished according to the canons of international "real design."

One began to wonder if it was really necessary to continue to sink into beige leather sofas, surrounded by fixture-walls with sharp-cornered orthogonal planes in shiny polyester, or to march up and down steps and floors covered by eternal monochromatic carpets, a painting here, a sculpture there, lighted by black, acid structures in steel and sheet-metal, drinks and hors d'oeuvres lined up on severe coffee-tables, possibly in chrome and glass.

A few Milanese architects and designers swore it wasn't, and with regard to this matter, in the winter of 1980, they were ready for a change — "revved up," as they put it.

Projects, attempts, and research, representing an important evolution away from the radical conceptualism of the previous years, had been around for some time. Even concrete experiments, physical trials, and public sorties had been made. There were all the ingredients for a good show, but the real show was yet to begin.

In 1977-78, Sottsass and Branzi had designed pre-Memphis furniture and lamps for Croff Casa (a chain of furniture stores) which turned out to be a dismal failure. (Salesmen actually discouraged clients from buying the pieces). The Croff pieces had already been studied not as part of coordinated systems, but as small, independent expressive mechanisms on which special communicative care was concentrated. They were already conceived as travel companions, pieces one could talk to, pieces if you will, closer to the "lost grace" (Branzi) of certain Biedermeier furniture of the nineteenth-century middle class than to the aggressive trend of current design with its special arrogance and presumption of representing and showing off an affluence immediately and for ever attained.

Then in 1979-80 the joint efforts of Sottsass, Branzi, De Lucchi, Mendini, and Navone with Studio Alchymia kept hope and controversy alive. They partially and temporarily fulfilled the desires of those who had managed to make a few prototypes, disillusioned others who were pushed aside or left out altogether, and stirred up within Alchymia itself, further discussions and other controversies.

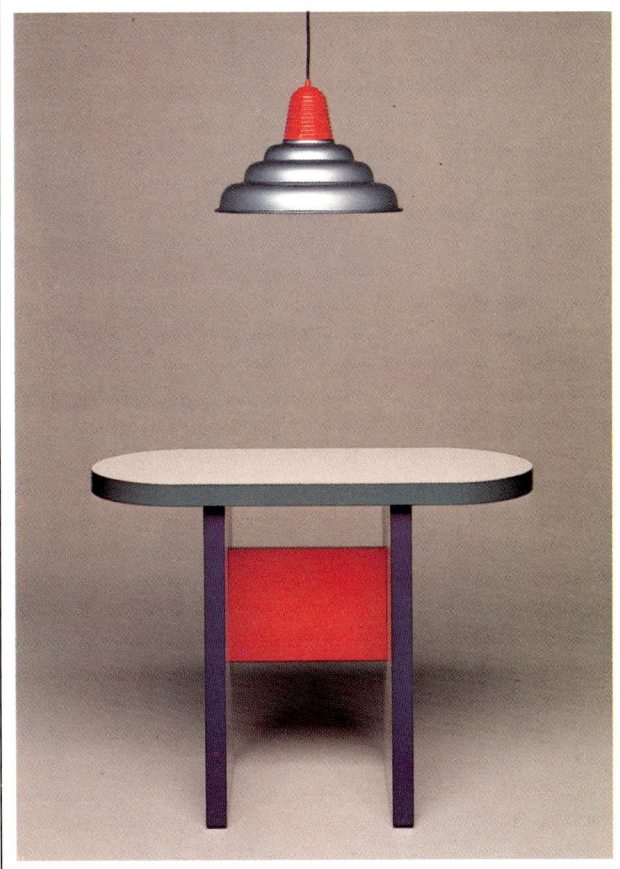

Hanging lamp in metal by Andrea Branzi and console table in HPL Print laminate by Ettore Sottsass for Croff, 1979.

Ettore Sottsass, drawing for a chair, 1979.

Alchymia started in 1976 as a graphic design studio. After a fairly nebulous début as a sponsor of radical and sometimes shoddy projects, it became, in 1978, the repository of the most important experimental developments of the Milanese post-radical avant-garde (a role it was to retain for the next two years). This avant-garde gravitated more or less around Mendini, Sottsass and to some extent Branzi. Old acquaintances, their friendship and professional relationship dated from the early seventies, when Mendini, then editor of Casabella, began to publish a debate on the problems of the radical avant-garde.

From that time on they never lost sight of one another, and they continued to discuss with more or less intensity the destinies of architecture and design.

Sandro Guerriero, founder of Studio Alchymia, met the others in 1978 through Alessandro Mendini. Guerriero had met Mendini during an exhibition of "radical suitcases" at Studio Alchymia, and had later helped him to make some furniture for an exhibition (in June 1978) at the Palazzo dei Diamanti in Ferrara, where Sottsass and Branzi were also exhibiting. The furniture, including the famous Proust armchair and Kandinsky sofa, was the first important result of Mendini's research into kitsch and the "banal." It was also his first attempt at "redesign." Enthusiastic about his work with Mendini, and having met Sottsass, Branzi, and friends in the meantime, Guerriero again set out in search of new outlets for his activity, declaring his readiness to carry out the projects that had been waiting impatiently to get off the drawing-board. This led to the 1979 and 1980 exhibitions at Studio Alchymia – the first public performances, the first opinion polls, the first checks and counter-checks. Notwithstanding the insults and the shrugged shoulders which the shows elicited from most of their colleagues, the designers were increasingly convinced that they were moving in the right direction. The difficulties, however, were enormous. Alchymia had been an important step in gathering and exchanging ideas, the first toward the launching of New Design. But two short years after the first meetings, some felt it was no longer working. The designers needed a manufacturer who would make not only experimental prototypes, but finished pieces as alternatives to standard production. Sandro Guerriero's interest lay mainly in producing exhibitions, promoting cultural activities. He failed to see however that in 1980, if such cultural enterprises were to succeed, they could not remain isolated provincial exercises in avant-garde or counterculture, refined as they might be. They had to have wider, higher ambitions; they had to get off the pedestal, throw off their artistic "aura" and to compete directly with industry in quality, quantity and image.

Alchymia had neither concerned itself with, nor succeeded in setting up even the shadow of a sales organization. The designers, on principle, did not want to have anything to do with original or numbered pieces and even less with art objects – exhibition pieces which would inevitably be read as aesthetic exercises, conceptual declarations. What they wanted to make was not collector's items, but furniture, to be sold in stores, taken home and used every day.

Further contrasts arose over the increasingly open ideological disagreement with Mendini, who continued to maintain a critical, pessimistic attitude to design, an attitude that had been typical of the radical controversy. His analysis of the "banal" as a method of design and his exercises in redesign, or make-up, or styling of more or less famous objects – exercises that were intended to show that "for a

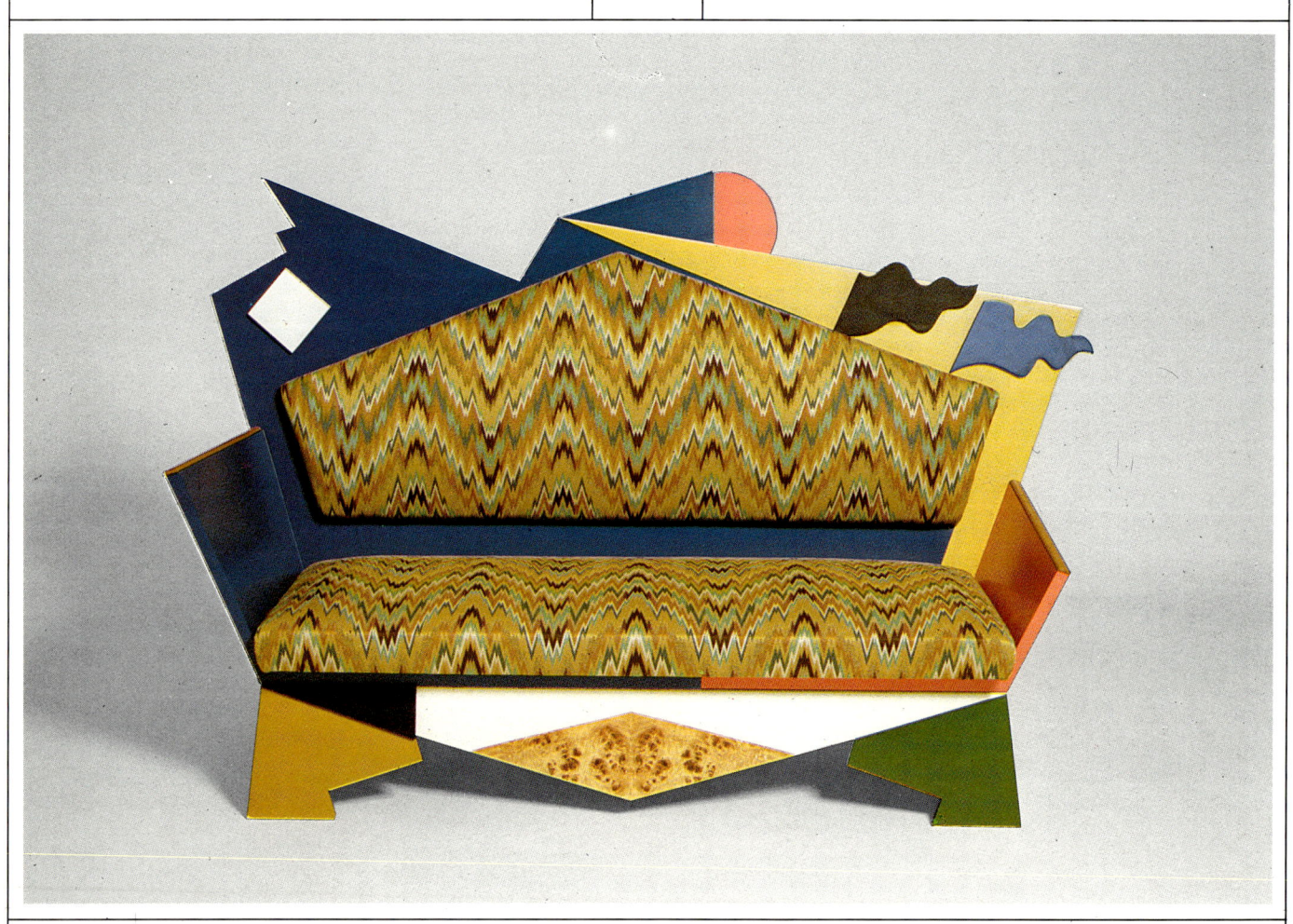

Alessandro Mendini, "Kandissi" sofa, Alchymia 1979.
Lacquered wood, briar-wood and *gobelin*.

future of at least ten years of design one can do nothing but redesign" – denied the immediate historical possibility of new outlets for research, on both the theoretical and the practical level. Besides, Mendini did not have a private studio, and in keeping with his theories of *progettista di frontiera*, he understandably tended to rely professionally on Alchymia, which identified increasingly with the Mendini line until it became what it is today: workshop and partner of his ideas and projects.

Thus Alchymia, which some (mainly Sottsass and De Lucchi) hoped from the very beginning would grow into Memphis, continued to follow its Alchymia fortune, and Memphis was born from the secession of those who were well determined to look for different destinies.

The Memphis secession was not a formal act nor did it follow a master plan. The break-up of the original Alchymia had been a slow process; the only person who really dropped out of Alchymia in the Fall of 1980 was Sottsass, and his was a silent secession, a shifting, a pause for reflection. A pause that was not destined to last long.

In October 1980 Sottsass was faced with two proposals. Renzo Brugola, an old friend and owner of a carpentry shop, declared his willingness to "do something together just like old times" (the sixties at Poltronova); and Mario and Brunella Godani, who had a showroom downtown, asked him for some of his "new furniture" for their store.

The counter-proposals made by Sottsass, who meanwhile had decided to leave Alchymia for good, laid the foundations of the future Memphis. In the autumn of 1981, Sottsass asked the Godanis to host a show of "very up-to-date" furniture designed by him and by some "very clever friends." He also asked his friend Brugola to produce the pieces, free of course. But even though Brugola and the Godanis showed their immediate support, there was still no talk of Memphis.

The name Memphis appears for the first time in a notebook belonging to Michele De Lucchi (the second to leave Alchymia), scribbled at the top of the first page, near a date, 11 December 1980. The second and third pages are dated "12 December at the pizzeria" and "14 December in Via San Galdino," which is where Sottsass lives.

Memphis was born on those three evenings. They were cold, winter evenings that nobody remembers very well. The surviving notes include only lists of names and numbers, of friends to invite, of countries to represent, of furniture to design, of months and days available for designing, producing, photographing and printing... no ideological notes, no comments by anyone.

The memories, which now seem prehistoric, when there are any, concern the hours passed in the Pizzeria Positano near Sottsass and De Lucchi's places, and those passed in the twenty square meters of Sottsass's living room, white wine, music, excitement, laughter, smoke, complicity.

No one talked on those evenings about "how" to

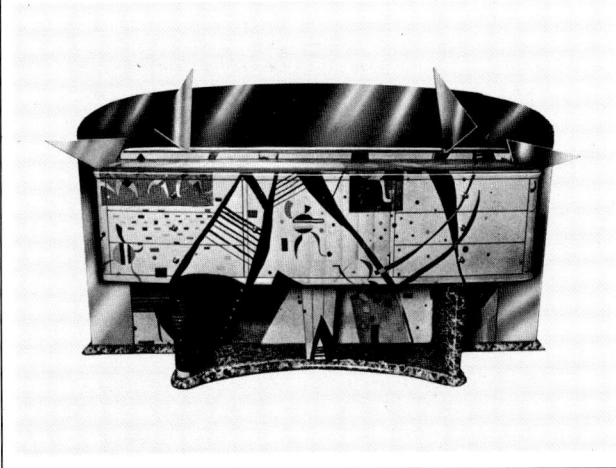

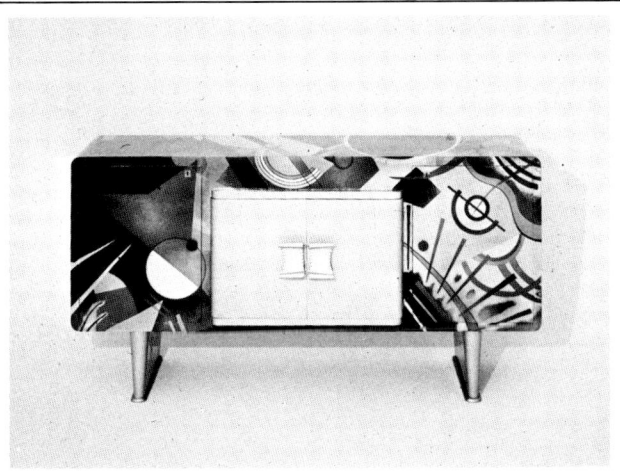

Alessandro Mendini, redesigns of sideboards, Alchymia 1978.

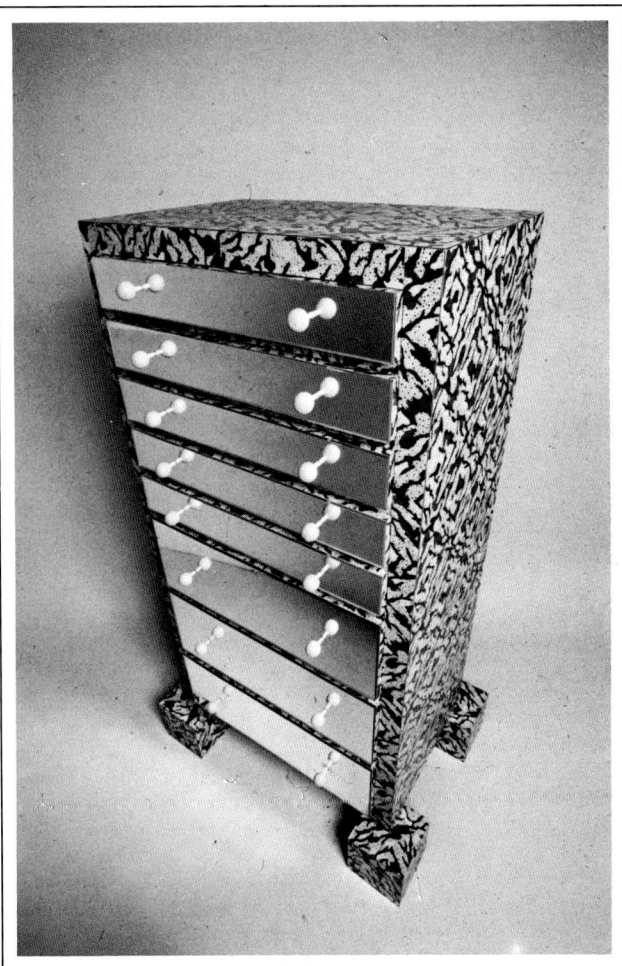

Paola Navone, "Gadames" dresser, Alchymia 1979. HPL Print laminate and mirror.

design. No one mentioned forms, colors, styles, decorations; as if by telepathy or celestial illumination, everyone knew exactly what to do, everyone knew that the others knew, or perhaps everyone pretended they knew. Certainly, they didn't say anything. Everyone kept his fears to himself.

The name Memphis must have come up on the evening of December 11 at Sottsass's house. There was a Bob Dylan record on, "Stuck Inside of Mobile with the Memphis Blues Again," and since nobody bothered to change the record, Bob Dylan went on howling "the Memphis Blues Again" until Sottsass said, "ok, let's call it Memphis," and everybody thought it was a great name: Blues, Tennessee, rock' n' roll, American suburbs, and then Egypt, the Pharaohs' capital, the holy city of the god Ptah. According to Michele De Lucchi's notebook, Ettore (Sottsass), Barbara (Radice), Marco (Zanini), Aldo (Cibic), Matteo (Thun), Michele (De Lucchi), and Martine (Bedin) were there that evening. Except for the author they were all architects (Bedin about to get her degree), and all but Sottsass were under thirty. Except for De Lucchi no one had worked with Alchymia, but for years they had all done nothing but talk about the same problems, and they were ready to start drawing. That evening George Sowden and Nathalie du Pasquier were missing.

The first drawings of New Design furniture were gone over on Monday, 9 February 1981, and that evening George and Nathalie were also present. There were more than a hundred drawings, and in the end everybody was drunk, but for the first time sure that Memphis would exist.

The next seven months before the opening, set for 18 September, were hectic, but somehow (no one knows how) long enough to do everything in time. Everything meant: to make the technical drawings of the furniture, produce the furniture, find a lamp manufacturer, produce the lamps, find a ceramics manufacturer, produce the ceramics, convince Abet Print to produce new plastic laminates, find a fabric manufacturer, produce the fabrics, communicate with foreign architects and designers behind schedule with their drawings, photograph the furniture, invent the graphics because there was no money to pay a studio, design two posters, an invitation, a catalogue, a press package, letterhead paper and envelopes, do a book, find the money and a publisher for the book, design the display, and write to journalists and the press. All this without funds and everyone with another full-time job. At the opening on September 18 there were thirty-one pieces of furniture, three clocks, ten lamps, eleven ceramics, and twenty-five hundred people.

We had even succeeded, in June, in finding a business man willing to form a company (together with Brugola, Godani and Fausto Celati, another investor) and to distribute Memphis on the international market. Ernesto Gismondi, president of Artemide, whom Sottsass had asked to produce a few lamps for Memphis, ended up as Memphis's president and majority shareholder.

Memphis opening, Milan, 18 September 1981,
Arc '74 Showroom.

Ettore Sottsass, "Rete," HPL Print laminate, 1979.
Ettore Sottsass, "Spugnato," HPL Print laminate, 1979.

Christoph Radl, "Onda," HPL Print laminate, Memphis 1982.
Christoph Radl, "Isole," HPL Print laminate, Memphis 1982.

Michele De Lucchi, "Fantastic," HPL Print laminate, Memphis 1981.
Michele De Lucchi, "Micidial," HPL Print laminate, Memphis 1981.

Michele De Lucchi, "Terrific," HPL Print laminate, Memphis 1981.
Michele De Lucchi, "Traumatic," HPL Print laminate, Memphis 1983.

Nathalie du Pasquier, "Craquelé," HPL Print laminate, Memphis 1983.
George J. Sowden, "Marmo," HPL Print laminate, Memphis 1983.

Ettore Sottsass, "Veneziana," HPL Print laminate, Memphis 1981.
Ettore Sottsass, "Serpente," HPL Print laminate, 1979.

Michael Podgorschek, "Argilla," HPL Print laminate, Memphis 1982.
Ettore Sottsass, "Rete 2," HPL Print laminate, Memphis 1983.

Ettore Sottsass, "Lamiera," HPL Print laminate, Memphis 1983.
Rudi Haberl, "Pastina," HPL Print laminate, Memphis 1982.

PLASTIC LAMINATE

One of Memphis's most important innovations, perhaps their greatest contribution to the turn of style that changed the face of contemporary furniture, has been the use of plastic laminates, and particularly of decorated plastic laminates, in furniture design. This seemed to some people a secondary issue, a matter of intellectual snobbery, a cheap trick, without thinking that the problem of materials in design is anything but marginal or incidental. The greatest changes in taste or style in architecture and in the applied arts have always been accompanied, or better yet defined, by interest in new available materials and technologies.

Using different materials provides not only new structural possibilities, but – above all – new semantic and metaphoric possibilities, other modes of communication, another language, and even a change of direction, broadening of perspective, appropriation and digestion of new values and the concomitant rejection of traditional structures that renewal always involves. With Memphis and plastic laminates, the renewal was generated by a violent switch of cultural context combined with, and magnified by, the introduction of an absolute novelty: surfaces decorated with patterns of the designer's own invention.

Plastic laminates certainly are not new. They appeared years ago on the tables and chairs of bars and coffee-shops, and today rule supreme in ice cream parlors, milk bars, movie theaters, take-out restaurants, Mc Donalds and Wimpys. With their sugary colors and fake wood, brick or wicker squiggles, they have become part of the mass urban scene, a symbol of suburbia, that anonymous hinterland, a little naive, a little desperate, but optimistic, positive and self-assured, which to define itself shrugs off both the culture of the city and that of the country, making its myths of modern materials, naturally absorbing all technological shocks, identifying body and soul with the future, knowing it "is" the future.

Plastic laminates made their way into the home years ago on account of their "practical and functional" qualities. Today they can even be found in the homes of the wealthy, but most of the time they are "hidden away" in closets, bathrooms, and kitchens, or at best in the children's room. They have never appeared in entrance halls or living rooms, the "formal" rooms entrusted with displaying the owners' status symbols and prestige. Plastic laminates today are still a metaphor for vulgarity, poverty, and bad taste. As a result they are also excluded from those public places that aspire to a certain standard of "elegance," be they restaurants or bars, night clubs, confectioner's shops or boutiques.

Martine Bedin, "Lodge" stand, Memphis 1982.
HPL Print laminate.

Memphis turned this situation upside down. It took plastic laminates and put them into the living room; it studied and explored their potential; it decorated them and glued them on tables, consoles, chairs, sofas, and couches, playing on their harsh, noncultural qualities, their acid-black corners, their ultimately artificial look, and the dull uniformity of their surface, which is void of texture, void of depth, void of warmth. And yet, as Emilio Ambasz has pointed out, these laminates are "forever young, eternally vibrant." The greatest novelty of Memphis's plastic laminates is their decoration and the most important feature of this decoration is its anonymity, its absence of signs, of quotations or metaphors associated with codified culture. The iconographic package of Memphis decorations comes, like the laminates, from unorganized cultural areas such as suburbs or growing cultures. The patterns are graphic formulations of brutally decorative geometric motifs, which in some instances, like Michele De Lucchi's "Micidial" and "Fantastic" patterns, even have names that recall the emphatic and paradoxical atmosphere of certain comic strips. Others evoke stereotypes of false Venetian blinds, false meshes, false serpents, even false masterpieces of painting. Or, as in Ettore Sottsass's now familiar "Bacterio" and "Spugnato" patterns, the laminates evoke neutral and anesthetizing organic forms. Patterned plastic laminates have been so important in the definition of New Design that their birth coincides with the research into new types of furniture undertaken by Sottsass following the 1977 agreement with Croff Casa. The first drawings for the "Bacterio" and "Spugnato" laminates date from this period and were later produced by Abet Print and used for the first time on the experimental furniture made for Abet Print and shown at Studio Alchymia in 1979.

It seems that the idea of patterned plastic laminate furniture came to Sottsass as he was drinking coffee at ten o'clock one morning at the pink-and-blue veined counter of a quasi-suburban milk bar near his house – a place frequented at that time of the morning by post-office employees and old ladies looking for cats to feed. Equally fortuitous and slightly decadent in a Klimt-like way, was the inspiration that struck Michele De Lucchi for his first pieces in Memphis laminate: he was watching teen-aged punks with talc-white faces painted in bright colors on New Year's Eve 1980-81 in Trafalgar Square. Both were instances of lightning inspiration, explosions of awareness only possible in brain cells already prepared for a certain chemical reaction, already hyped for a solution that had been a long time coming. And both were cases of socio-linguistic inspiration, of messages more anthropological than decorative. This is probably why Memphis decorations had such a forceful and immediate impact in so many different fields. Soon after their début in furniture design, they appeared on T-shirts and sweaters, as a graphic support in magazines, and even printed on a famous new-wave brand of shoes. Given the demand, Abet Print has put three designs in its general catalogue and is preparing a separate Memphis catalogue with patterns by Sottsass, De Lucchi, and other designers chosen by Memphis in a workshop on decoration set up by Sottsass at the Kunstgewerbeschule in Vienna.

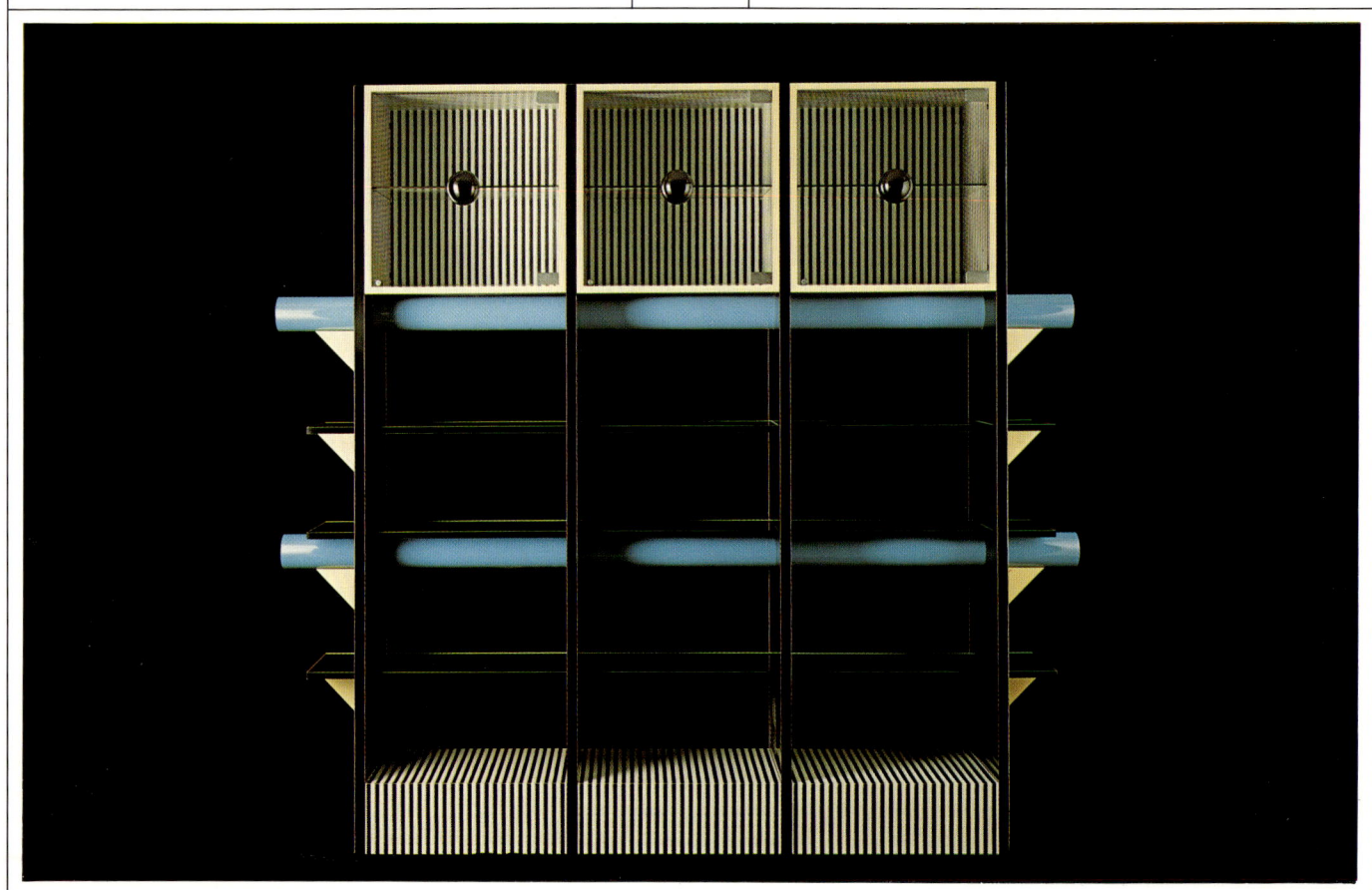

Michele De Lucchi, "Phoenix" bookcase, Memphis 1983.
HPL Print laminate, metal and glass.

Ettore Sottsass, "Casablanca," Memphis 1981.
HPL Print laminate.

The Past Is a Luxury
"The housemaid turns on the lamps: it's only 2 p.m. but the sky is completely black... people are at home, no doubt they too have turned on the lights. They read, they watch the sky from the window. For them things are different. They have aged differently. They live among bequests and gifts and their every piece of furniture is a memory. They have closets full of bottles, fabrics, old clothes, newspapers; they have kept everything. The past is a luxury reserved for the rich..."
Jean-Paul Sartre, *La Nausée*

George J. Sowden, interior design, 1983.

George J. Sowden, interior design, 1983.

George J. Sowden, "Oriental" bed, Memphis 1982. HPL Print laminate, bedspread in cotton print produced by Rainbow. Fabric design by Nathalie du Pasquier.

Michele De Lucchi, "Pacific" wardrobe, Memphis 1981.
HPL Print laminate, metal and printed glass.

The Air Smelled of Face Powder

"... The room was dim with shades across two front windows. The air smelled of face powder. There was light-painted furniture, a pull-down double bed which was pulled down but had been made up... On the dresser there was a composition toilet set, neither cheap nor expensive... in the bathroom, nothing. In a closet behind the bed a lot of clothes and two suitcases. The shoes were all one size. Steve stood beside the bed and pinched his chin. 'Blossom, the spitting blonde, doesn't live here' he said under his breath. 'Just Marilyn the torn-pants brunette'..."

Raymond Chandler, *The King in Yellow*

Nathalie du Pasquier, interior design, 1983.

Nathalie du Pasquier, interior design, 1982.

Andrea Branzi, interior design, 1983.

Michael Graves, "Stanhope" bed, Memphis 1982.
Maple root, lacquered wood, mirror,
glass and brass.

The West Room

"... A west room of the main southeast hall was made ready to receive her. New curtains were hung and new screens set out, as were forty cushions, more comfortable and less ostentatious, thought Genji, than ceremonial chairs. In spite of the informality, the details were magnificent. Wardrobes were laid out upon four cupboards inlaid with mother-of-pearl, and there was a fine though modest array of summer and winter robes, incense jars, medicine and comb boxes, inkstones, vanity sets, and other festive paraphernalia. The stands for the ritual chaplets were of aloeswood and sandalwood, beautifully carved and fitted in the modern manner, with metal trimmings in several colors..."
Murasaki Shikibu, *The Tale of Genji*

Michael Graves, "Plaza" dressing table, Memphis 1981.
Maple root, lacquered wood, mirror,
glass and brass.

Michael Graves, drawings for a dressing table,
Memphis 1981.

Michael Graves, studies of ashtrays, 1982.

Michael Graves, studies of pepper shakers, glasses, clocks, and ashtrays, 1982.

Michael Graves, studies of a lamp and table, 1982.

Michael Graves, notes, 1982.

Peter Shire, drawing for an armchair
and drawing for a dressing table, 1981.

Peter Shire, drawing for an armchair and drawing for a chair, 1982.
Drawing for a table, 1981.

Peter Shire, drawing for a sidetable, 1982.

Peter Shire, "Brazil" table, Memphis 1981.
Lacquered wood.

Javier Mariscal, "Hilton" serving cart, Memphis 1981.
Metal and sheet glass.

Hans Hollein, "Schwarzenberg" table, Memphis 1981.
Aniline-dyed briar, wood,
and gilded wood.

Do You Drink Wine?
"As soon as they entered the library, servants removed their outer garments, and Hsi-men called for his scholar's cap. The fierce eyes of the long bearded monk looked round the hall as if he had never seen such a place, and Hsi-men maintained a humble silence. The walls were covered with scroll pictures, the bamboo rods being decorated with jade and cornelian, and the curtains across the entrance were of such fine threads that the material was called 'shrimp-whisker Silk.' The rugs on the floor had designs of lions and phoenixes, and the chairs were exquisitely carved from southern blackwood. A marble table top was set below the Ancestral Tablets. Do you drink wine esteemed Master? Hsi-men enquired at last..."
Wang Shih-cheng, *Chin-P'ing-Mei*

Andrea Branzi, "Century" couch, Memphis 1982.
Metal, lacquered wood and cloth.

Ettore Sottsass, drawings for lamps, 1981.

Ettore Sottsass, drawings for lamps, 1981.

George J. Sowden, drawings for clocks, 1981.

George J. Sowden, drawing for a table, 1981.

Shiro Kuramata, "Imperial" chests, Memphis 1981.
Lacquered wood.

MATERIALS

The plastic laminate shock, besides opening up new perspectives in furniture design, paved the way for a series of reflections, revisions, and research into the theme of materials, their quality, their possible combination and matching, their semantic and cultural charge. As a result, materials have begun to be read, chosen and utilized not only as tools or supports of design (important as these may be), but as active protagonists, privileged vehicles of sensory communication, self-sufficient cells that cohabit the design without mixing, each cell with its own personal story to tell. Marco Zanini points out: "Hoffmann often used precious materials like mother-of-pearl to draw lines. They were lines of mother-of-pearl, but they were essentially lines. If *we* use mother-of-pearl, we use square miles of it, because it's the mother-of-pearl that tells its story and not the line." The Memphis designers have worked on materials in two senses: developing and using "aseptic," freedom-giving materials that have not been consumed by institutionalized cultures, and putting them together with bits or pieces of cultivated materials "to see if something else can be done." This, as Sottsass explains, is a phenomenon that very often repeats itself in history, for instance when barbarians with their "nonculture" invade civilized zones.

Every institutionalized culture possesses a very precise catalogue of signs, ordered and assembled to represent the most general meaning that can be given to that culture. This catalogue makes it possible to communicate certain situations, to express certain things and not others, and everything is okay as long as a culture is still growing, fermenting and expanding. But when a culture reaches the point of boredom, when one begins to want to say other things, and especially when, according to Sottsass, "one is not able to say the things one thinks must be said," then a "change of air" is necessary. New supports must be found in the "no-man's-land" of germinal cultures, where signs still have a sexy charge, a bittersweet flavor, and arouse shivers of surprise or pleasure because they still stagger in a kind of prenatal limbo, because no one has yet charged them with symbols and meanings, because, as De Lucchi says, "you don't relate them yet to anything or anybody and you can project new possibilities onto them right away."

In addition to plain or patterned plastic laminates, the Memphis catalogue of "aseptic" materials includes many other industrial products: printed glass, zinc-plated and textured sheet-metals, celluloids, fireflake finishes, industrial paints, neon tubes, colored light bulbs, and so on. In the Memphis context these materials lose their high-tech connotations because they are never quoted as technological symbols but as textures, patterns, color, density, transparency and glitter. They are immediate and directly sensual. Moving in this freedom-giving context, which appeals more to physical qualities than to the intellect, Memphis designers have even succeeded in revitalizing cultivated, traditional, and familiar materials. Marble, for instance, is used in irreverent forms that do not correspond to recognized uses of that material, or it is taken out of context by coupling it with aluminum, fiberglass, or fireflake paints.

Many materials have been thrown off balance, stretched, and deformed to the point of becoming unrecognizable. Once a perplexed British journalist, stroking a bookcase in natural polished briar (used alongside a yellow and green snakeskin laminate in the same piece of furniture, Sottsass's Beverly) sighed, "fantastic, it looks like plastic."

Actually the problem isn't to make one thing look like another, nor to make it look like itself: whether it is marble that looks like plastic, plastic that looks like wood, or plastic that looks like plastic is of little importance. For Memphis designers the problem of truth and authenticity, and vice versa, the problem of fake, doesn't exist. What matters is the image, the design, the final product, the figurative force, the communication. As with many pupils of Buddha, all Memphis designers seem convinced that "reality" as an absolute doesn't exist, or if it does exist, it is what is. The free and easy, anarchic, and unrestrained use of unforeseen and unforeseeable materials, the combined use of heterogeneous, cheap and expensive materials, of rough and smooth textures, of opaque and sparkling surfaces, tend in the end to turn a piece of furniture into a complex system of communication. It becomes a small metaphorical novel, a story of volumes and surfaces, of signs and groups of signs, of their different flavors, and of the inner changes they undergo in order to appear in strange, attractive combinations and create new expressive circuits. What's more, this linguistic earthquake has definitively altered the traditional image of formal coherence and compactness, laying the foundations for a future, more flexible and sophisticated stylistic syntax.

Crossing the Hall
"... Hear while I describe for you your quiet and reposeful home.
High walls and deep chambers, with railings and tiered balconies;
Stepped terraces, storied pavilions, whose tops look on the high mountains;
Lattice doors with scarlet interstices, and carvings on the square lintels;
Draughtless rooms for winter; galleries cool in summer; ...
Crossing the hall into the apartments, the ceilings and floors are vermilion;
The chambers of polished stone, with kingfisher hangings on jasper hooks;
Bedspreads of kingfisher seeded with pearls, all dazzling in brightness;
... Many a rare and precious thing is to be seen in the furnishings of the chamber;
Bright candles of orchid-perfume fat light up flower-like faces that await you..."
Chao hun, *The Summons of the Soul* (Chou dynasty)

Andrea Branzi, "Gritti" bookcase, Memphis 1981.
Metal, HPL Reli-tech Print laminate, natural ash
and plate glass.

Marco Zanini, "Dublin" sofa, Memphis 1981.
HPL Print laminate, metal and woollen fabric.

Ettore Sottsass, "Beverly," Memphis 1981.
HPL Print laminate, poplar root and metal.

Michele De Lucchi, "Sebastopole" table,
Memphis 1982. Marble and pietra serena. Produced
by Up & Up, Massa.

Karl Lagerfeld apartment, Montecarlo.
In the foreground, Sottsass's "Beverly." On the left,
Zanini's "Dublin" sofa, Memphis 1981.

The House of the Citizen
"A man who is educated and who possesses a fortune should become the head of a household and live the life of a useful citizen. He should choose to live in a town or a large village, or in an honest neighbourhood, or in some crowded locality. His house should be situated near running water and should be divided into diverse sections for different uses. The dwelling should be surrounded by a garden and should contain two apartments, an exterior and an interior one. The inner apartment should be reserved for the women of the house. The exterior one should be richly perfumed and should contain a huge soft bed covered with a spotless white sheet, slightly raised towards the centre and surrounded by garlands and bowls of flowers. The bed should be covered by a canopy overhead, and there should be two pillows, one for the head and one for the foot. The room should also contain a sofa, and above this there should be a small shelf to hold the perfumed ointments for the night, flowers, pots of collyre and other perfumes used to freshen the breath, as well as several lemon peels. On the floor near the sofa there should always be a brass spittoon, a jewel box, a lute hung on an elephant tusk, a drawing table, perfumes, some books and garlands of yellow amaranth. The room should also contain a round seat, a box of games and a dice table. In the outer apartment there should be a cage for birds, and a separate little room should be kept for sculpturing and fashioning wood and other such diversions. In the garden there should be a revolving swing as well as an ordinary one, also a summer house and benches to sit on. In the morning, the head of the house, after he has done his indispensable duties, must wash his teeth, apply moderate quantities of perfumes and oils to his body, put mascara on his lids and eyes, and colour his lips with alacktaka, and then study the whole effect carefully in the mirror. Then, having chewed some 'pan' and other such things that freshen the breath and sweeten the taste in the mouth, he should go about his daily duties. He should take a bath every day. Every second day he should anoint his body with oil; every third day he should rub a foamy substance on his body; every fourth day he should shave his face and head, and every fifth or tenth day the other parts of his body."
Vatsyayana, *Kamasutra*

Karl Lagerfeld apartment, Montecarlo. Bed by Michele De Lucchi. Bedspread by Nathalie du Pasquier. On the right, "Kristall" table by De Lucchi and "Cavalieri" lamp by Sottsass. On the left, "Hilton" serving cart by Mariscal and "Tahiti" lamp by Sottsass, Memphis 1981.

Karl Lagerfeld in his Montecarlo apartment. "Pierre" table by Sowden, "Riviera" chairs by De Lucchi, "Treetops" lamp and "Suvretta" bookcase by Sottsass, Memphis 1981. Ceramics by Matteo Thun.

George J. Sowden, "d'Antibes" showcase, Memphis 1981.
Lacquered and silkscreened wood.

Michele De Lucchi, "Atlantic" dresser, Memphis 1981.
HPL Print laminate, metal and glass.

The Radiator Room

"... I remember, for example, two small, black, cast-iron radiators, which stand in two corresponding corners of a small room. The symmetry alone of the two black objects in the light room gives a feeling of well-being! The radiators are so flawless in their proportions and in their precise, smooth, slender form, that it was not noticeable when Gretl used them after the cold season as a base for one of her beautiful art objects. One day when I was admiring these radiators, Ludwig told me their story and of his own difficulties, and how painfully long it had taken until the precision which constitutes their beauty had been reached. Each of these corner radiators consists of two parts, which stand precisely at right angles to each other, and, between them, calculated down to the millimeter, a small space has been left; they rest on legs upon which they had to fit exactly. At first, models were cast, but it soon turned out that the kind of thing Ludwig had in mind could not be cast in Austria. Consequently, ready-made castings for individual parts were imported from abroad, although at first it seemed impossible to achieve with these the kind of precision which Ludwig demanded. Entire sets of pipe sections had to be rejected as unusable, others had to be exactly ground to within half a millimeter. The placing of the smooth plugs, too, which were produced in accordance with Ludwig's drawings by a quite different process from the conventional products, caused great difficulties. Under Ludwig's direction, experiments often went on into the night until everything was exactly as it should be. As a matter of fact, a whole year passed between the drafting of the seemingly so simple radiators and their delivery. And yet, I consider the time well spent when I think of the perfect form which arose from it."

Hermine Wittgenstein, *Family Recollections*

Michele De Lucchi, "Riviera" chairs, Memphis 1981.
Metal, HPL Print laminate and chintz.

George J. Sowden, "Oberoi" armchairs, Memphis 1981.
Cotton print produced by Rainbow. Fabric design
by Nathalie du Pasquier.

Ettore Sottsass, "Mandarin" table, Memphis 1981.
HPL Print laminate, lacquered wood, metal and plate glass.

However Much Taste May Change

"'I was just thinking,' said Lord Merlin, 'that, however much taste may change, it always follows a stereotyped plan. Frenchmen used to keep their mistresses in *appartements*, each exactly like the other, in which the dominant note, you might say, was lace and velvet. The walls, the bed, the dressing-table, the very bath itself were hung with lace, and everything else was velvet. Nowadays for lace you substitute glass, and everything else is satin. I bet you've got a glass bed, Linda?'
'Yes – but...'
'And a glass dressing-table, and bathroom, and I wouldn't be surprised if your bath were made of glass, with goldfish swimming about in the sides of it. Goldfish are a prevailing motif all down the ages.'
'You've looked' said Linda sulkily, 'very clever.'
'Oh, what heaven' said Davey, 'So it's true!'..."

Nancy Mitford, *The Pursuit of Love*

Ettore Sottsass, drawings for a table, 1981.

Ettore Sottsass, "Suvretta" bookcase, Memphis 1981.
HPL Print laminate.

Masanori Umeda, "Tawaraya" ring, Memphis 1981. Wood, metal, straw mats. In the ring
from the left: Aldo Cibic, Andrea Branzi, Michele De Lucchi, Marco Zanini,
Nathalie du Pasquier, George J. Sowden, Martine Bedin, Matteo Thun, Ettore Sottsass.

Christoph Radl, Memphis logo, 1982. Valentina Grego, Memphis logo, 1983.
Christoph Radl, Memphis logo, 1983. Christoph Radl, Memphis logo, 1983.

Cover of the book, *Memphis, The New International Style*, Electa, 1981.

Michele De Lucchi, drawings for lamps, 1981.

Michele De Lucchi, drawings for lamps, 1981.

Michele De Lucchi, "Oceanic" lamp,
Memphis 1981. Metal.

The Dining Room
"... To get into the dining room you walk up three steps, open a pair of doors and walk out on a platform, and then walk down three steps. Now the dining room is at exactly the same level as my lobby, but as they walk up they reach the platform. I've got soft light lighting this thing up, and before they're seated, they are on stage as if they had been cast for the part. Everybody's looking at them; they're looking at everybody else..."
Morris Lapidus, quoted in *Progressive Architecture* (September 1970)

DECORATION

Memphis is also primarily concerned with decoration and the role that decoration plays within the design.
In this respect Memphis designers are very categorical, very anarchical, very radical.
As Sottsass points out, "Decoration as we imagine it involves disregard of the support structure as the basic structure of the design. People have always 'believed' in the basic structure; they have always believed that that structure 'had' to exist; they have always believed in the design as a succession of moments and in the unalienability of mental structures, as earnestly as they have believed in the principle of causality. We tend to imagine the design as a series of accidents that come together by chance; we imagine a possible sum, not an inevitable story. And what we believe holds this story of accidents together and gives it meaning, is that every accident has a formal, decorative identity. A Memphis table is decoration. Structure and decoration are one thing."
Michele De Lucchi also believes firmly in decoration as a key element in the reinvention of figuration and of image. He says: "In a traditionally designed object the surface is a single unit. Until four of five years ago people devoted all their energy to making surfaces homogeneous, associable, and continuous. Today the tendency is to see the design not so much as a unit but as a sum of parts. We have almost come to study the cells that make up objects more than the objects themselves. Materials and decoration are cells of objects, and they are part of this process."
This change of attitude corresponds to a dive from the certainties of the macrocosm to the virtual universe of particles, from a world borne by the laws of deterministic logic to a world interpreted through the hypotheses of probability. Objects are no longer designed from the outside according to a certain idea of structure; they are genetically engineered from the inside in an inverse process that adapts the final structure to the variable logic of its constituent parts.
At this point the question at issue is no longer mere formal innovation – adding, subtracting, or changing the direction of things – but the radical subversion of the epistemology of the design. The design is no longer a solution, but a hypothesis. It is not a definitive declaration, but a stage, a transitory moment, a container of possibilities, an unstable living form that evolves in time.
Sowden also feels that decoration is fundamental, and that it coincides with the search for a future aesthetic. He says: "Functionalism has now become a

Nathalie du Pasquier, rug design, 1982.

style, just as Japanese technological design is a style. But no one ever said that things have to be that way. With electronics, we are rapidly moving toward another kind of technology that involves other possibilities, other facilities, and a different relationship to the world – more sophisticated, more elastic, less moralizing, and less austere. Electronics is also decoration, play, color. Decoration belongs to the world of electronics just as functionalism belonged to that of the machine."

Memphis furniture – particularly the pieces designed by Sottsass, Sowden, and De Lucchi – is built by decoration. The works of Memphis designers are assemblages, agglomerates, multitudes, clusters, heaps, deposits of decorations that overlap, intersect, add up and flow together, but always maintain their linguistic independence. They are never subordinated to one another and they are never subordinated to the design.

Typical Memphis decoration is generally nondirectional, homogeneous, repeatable, abstract. It tends to disrupt the stability of static structures and, suggesting a hypothetical expansion of the pattern in all directions, it blurs the object's outlines. It is born with the design as an organic image of its molecular structure. It comes to the surface with the same logical naturalness as the grain in a piece of wood. The truly disconcerting thing is its obvious, peremptory "necessity."

Looking at Memphis patterns one gets the impression that they have always existed as part of the natural order of things – however weird – just like undulated sheet metal, TV, advertising, airplanes and football. They are so obvious that virtually no one has even talked about them in the two-hundred-odd publications that have come out in a year and half since their public début.

The special qualities of Memphis decorations are their inert, aphonic neutrality, their deliberate lack of learned references (which make it possible to keep a clear mind and to glide over them weightless), and their brutal figurative indifference. These quasi-mechanical, assembly-line-like qualities are the outcome of the avalanche of brain-racking inquiry, checks, double-checks, trials and research that followed the first Bacterio designed by Sottsass in 1978. I remember all too well seeing friends' offices overwhelmed by thousands of xeroxes of almost identical patterns, and listening to endless discussions – broken by long, very Japanese silences – over what to print and whether in positive or negative. Most of the patterns are photographic enlargements of the most disparate "sets" of things, such as coffee beans, rice, pasta, salad, clay, liquid surfaces or Letraset figures. Some are line drawings of photographs or of other drawings; others are ink or dot-pattern drawings. Some were born as "independent," generic patterns; others are motivated and "specific," like De Lucchi's wicked, hard, aggressive patterns bristling with edges and points, to contrast with soft, undulating forms and pastel shades in the designs for Memphis '81 and in the Hi-Fi series.

Also typically Memphis are the patterns designed by Nathalie du Pasquier. Nathalie is a kind of natural decorative genius – anarchic, highly sensitive, wild, abstruse, capable of turning out extraordinary drawings at the frantic pace of a computer. Her visual research is unrestrained, it absorbs everything like a sponge and nothing in particular. In the end it's the collage that counts.

Her hard, aggressive, acid patterns, her harsh, sharp, flat colors, her broad, black, angular mark make no compromise. They are impervious to logic, and they are so tight that they verge on agoraphobia. They embrace Africa, Cubism, Futurism, and Art Déco; India, graffiti, jungles and town; science fiction, caricature, aborigenes, and Japanese comics. They are enthusiastic, explosive, exalted, elated, as striking as neon in a tropical night. Thinking about them gives you the creeps. Nathalie says that decoration lays bare the soul of things.

Matteo Thun, "Nefertiti" sugar bowl and teapot, and "Tuja" vase, Memphis 1981. Produced by Ceramiche Flavia, Montelupo Fiorentino.

Nathalie du Pasquier, George J. Sowden, drawing for bed and bedspread, 1982.

Nathalie du Pasquier, "California" and
"Arizona" rugs, Memphis 1983. Hand-woven wool.
Produced by Elio Palmisano.

Marco Zanini, "Union" bookcase, Memphis 1983.
HPL Print laminate and metal.

Nathalie du Pasquier, fabric designs, 1981-82.

Nathalie du Pasquier, "Kenya," "Gabon,"
"Zaire," and "Zambia" fabrics, Memphis 1982. Chintz.
Produced by Rainbow, Milan.

Nathalie du Pasquier, "Royal" sofa, Memphis 1983.
HPL Print laminate and
"Cerchio" cotton print produced by Rainbow.

Nathalie du Pasquier, drawing for a sofa, 1983.

George J. Sowden, "Savoy," Memphis 1983.
HPL Print laminate, wood and glass.

Ettore Sottsass, sofa for Alcantara,
1982. HPL Print laminate and
printed Alcantara fabric.

Ettore Sottsass, "Agra" sofa, Memphis 1982. Marble and "Zambia"
chintz. Fabric design by Nathalie du Pasquier. Fabric
produced by Rainbow. Sofa produced by Up & Up, Massa.

Ettore Sottsass, "Malabar," Memphis 1982.
Briar, metal and HPL Print
laminate designed by Mario Radice.

The House of Dust

"... He turned his stare towards me, and he led me away to the palace of Irkalla, the Queen of Darkness, to the house from which none who enters ever returns, down the road from which there is no coming back. There is the house whose people sit in darkness; dust is their food and clay their meat. They are clothed like birds with wings for covering, they see no light, they sit in darkness. I entered the house of dust and I saw the kings of the earth, their crowns put away for ever; rulers and princes, all those who once wore kingly crowns and ruled the world in the days of old. They who had stood in the place of the gods, like Anu and Enlil, stood now like servants to fetch baked meats in the house of dust, to carry cooked meat and cold water from the water-skin.
In the house of dust which I entered were high-priests and acolytes, priests of the incantation and of ecstasy; there were servers of the temple, and there was Etana, that king of Kish whom the eagle carried to heaven in the days of old..."
The Epic of Gilgamesh

Michele De Lucchi, drawings for a table, 1982.

Michele De Lucchi, drawings for a desk
and file cabinet, 1982.

Aldo Cibic, "Belvedere" console, Memphis 1982.
Marble, granite, pietra serena and lacquered wood.
Produced by Up & Up, Massa.

Shiro Kuramata, "Ritz" writing desk, Memphis 1981.
Lacquered and bleached wood.

The Tea House

"... It is in fact the 'House of Fantasy,' for it is just an ephemeral building, a shelter for poetic feelings. It is also the 'House of Emptiness,' for it is free of all ornament, except for what little is necessary to satisfy the aesthetic aspiration of the moment. Finally, it is the 'House of Asymmetry' in that it is destined for the cult of the incomplete, and some small detail is always left unfinished, so that it may be completed by the play of the imagination..."

Okakura Kakuzò, *The Book of Tea*

Aldo Cibic, "Madison" lamp,
Memphis 1983. Metal.

Martine Bedin, "Holiday" lamp,
Memphis 1983. Aluminum.

Martine Bedin, "Western" lamp,
Memphis 1982. Metal.

Martine Bedin, "Super" lamp,
Memphis 1981. Fiberglass.

Ettore Sottsass, "Tahiti" lamp, Memphis 1981.
HPL Print laminate and metal.

Matteo Thun, "Kariba" fruit dish, Memphis 1982.
Decorated white porcelain.
Produced by Porcellane San Marco, Nove, Bassano.

Matteo Thun, "Manitoba" serving tray, Memphis 1982.
Decorated white porcelain. Produced by Porcellane
San Marco, Nove, Bassano.

Matteo Thun, Memphis porcelain 1982. Produced by
Porcellane San Marco, Nove, Bassano. Marble
console by Aldo Cibic, produced by Up & Up, Massa.

Matteo Thun, "Titicaca" vase, "Chad" teapot, "Garda" amphora, and "Onega" cup, Memphis 1982. Decorated white porcelain. Produced by Porcellane San Marco, Nove, Bassano.

Matteo Thun, "Volga" vase, Memphis 1983.
White porcelain. Produced by
Porcellane San Marco, Nove, Bassano.

Matteo Thun, "Santa Ana" and "Santa Monica"
ceiling lamps, Memphis 1983. Ceramics. Produced by
Porcellane San Marco, Nove, Bassano.

Matteo Thun, dish drawings for horizontal menus, 1983.

Ettore Sottsass, "Tigris" vase, Memphis 1983.
White and blue porcelain. Produced by
Porcellane San Marco, Nove, Bassano.

Ettore Sottsass, "Euphrates" vase, Memphis 1983.
White, yellow, and black porcelain. Produced by Porcellane
San Marco, Nove, Bassano.

Daniela Puppa, "Antarctic" serving tray, Memphis 1982.
Silver and lacquered wood. Produced by Rossi e
Arcandi, Monticello Conte Otto, Vicenza.

Nathalie du Pasquier, "Reykjavik" serving tray, Memphis 1982.
Silver and wood. Produced by Rossi e Arcandi,
Monticello Conte Otto, Vicenza.

Andrea Branzi, "Labrador" sauce boat, Memphis 1982.
Silver and plate glass. Produced by Rossi e Arcandi,
Monticello Conte Otto, Vicenza.

Peter Shire, "Anchorage" tea pot, Memphis 1983. Silver
and lacquered wood. Produced by Rossi e Arcandi,
Monticello Conte Otto, Vicenza.

Ettore Sottsass, "Murmansk" fruit dish, Memphis 1982.
Silver. Produced by Rossi e Arcandi,
Monticello Conte Otto, Vicenza.

Why He Loved Silver So Much I Don't Know
"... Why he loved silver so much I don't know. It must have been an amphetamine thing – everything always went back to that. But it was great, it was the perfect time to think silver. Silver was the future, it was spacy – the astronauts wore silver suits – Shepard, Grissom, and Glenn had already been up in them, and their equipment was silver, too. And silver was also the past – the Silver Screen – Hollywood actresses photographed in silver sets.
And maybe more than anything, silver was narcissism – mirrors were backed with silver. Billy loved reflecting surfaces..."
Andy Warhol, Pat Hackett, *POPism*

FINITO IL
14. MARZO 1982
A MILANO.
ALLE 2 DI NOTTE.

Ettore Sottsass, drawings for silver objects, 1982.

Ettore Sottsass, drawings for silver objects, 1981.

Matteo Thun, "Bering" fruit dish, Memphis 1982.
Silver and marble. Produced by Rossi
e Arcandi, Monticello Conte Otto, Vicenza.

Ettore Sottsass, "Alaska" vase, Memphis 1982.
Silver. Produced by Rossi e Arcandi, Monticello
Conte Otto, Vicenza.

COLOR

Prior to Memphis, there was no color in furniture. With a few exceptions the idea of furniture as a center of color didn't exist in the West. European furniture, on the whole, is made of "matter;" color comes into play only as a detail in mother-of-pearl, ivory, or bronze inlays, and in marble intarsia works. Even the exceptions are few and far between: the extremely tenuous, lacquered colors of certain eighteenth-century Venetian furniture, the black and white lacquers of certain Viennese furniture, tiny details of color in Jugendstil furniture, and naturally De Stijl, where primary colors alone are used in an ideological manner. In De Stijl, as later in the Bauhaus, color is chiefly "structural;" it emphasizes the way the furniture is built. Rietveld's "red and blue" chair, when it was designed in 1917, was not red and blue at all; the color was added after 1919, apparently at van Doesburg's suggestion.

In Memphis, color has never been an ideological vehicle. It does not exemplify building processes, nor does it sink its roots in stories of chromatic symbolism; it may be indirectly provocative, but it is above all a matter of linguistics. Introduced together with decoration in the software of design, color is one of the active ingredients of the complex messages transmitted by the furniture object. It works as an enzyme to catalyze chemical reactions, it generates nervous impulses that open new doors of logic in the brain, it is a sort of perceptive jogging, an aerobics for lazy or drowsy sensory cells. Like jogging, it requires commitment, determination, measure, enthusiasm, faith, and patience; and to serve a purpose, it must be used well.

Color in Memphis is never "added." As with decoration it is born with the design, forming an integral part of the structure. It alters the objects' molecules. It works as a mass, as an intrinsic feature of a certain form and volume. It is always a pigment and never a patina. "For this reason," explains Michele De Lucchi, "there are no dominant colors or background colors in Memphis." Memphis color does not work through the set relations of a chromatic system, but through proximity, as in the East (from India to Persia) or in Matisse (who learned color from oriental painting). The juxtaposition of colored masses, materials, and volumes, like little taps on a tuning-fork, make the whole color vibrate, creating resonances, dissociations, even linguistic reverberations that respond from afar. Sottsass calls them "long-distance correspondences."

Memphis didn't just bring color into the game, but made sure to play it as a winning card; Memphis color isn't only sensational because it is there but because it is new-made.

Sottsass says: "Anything that is tamed by culture loses its flavor after a while, it's like eating cardboard. You have to put mustard on it or take little pieces of cardboard and eat them with tomatoes and salad. It's a lot better if you don't eat cardboard at all."

At Memphis very little cardboard has been eaten. Memphis color, especially that of the early days, is devoid of cultural references. It is hard, disjointed, shrill, totally toneless and free of chromatic laxity. It is flat, literal, without suggestions. It doesn't live on

Arata Isozaki, "Fuji" sidetables, Memphis 1981. Wood.

reverberations and depth like most ancient color, which is almost always allusive; nor is it related to the polished abstractions of De Stijl. Its chromatic quality doesn't even resemble that of oriental color, which often is equally intense, sharp and showy, but soft, very soft, sweet and sensual, full of joy and drenched with flavor. Memphis color is comic-strip color (De Lucchi, Bedin), plastic color, hot dogs, sundaes, artificial raspberry syrup color (Peter Shire). It is washed out, cheap gouache color (Zanini), ridiculous color (Sottsass), naive color (Sowden), third-world color (du Pasquier). In any case, whether it is picked up in California, the lower Mediterranean, Africa or Brianza, it is motel color, suburban color, five-and-dime color.

This principle holds true in most cases, almost always. But color in Memphis follows no fixed pattern or rigid guideline. Instead, as Zanini points out, it is "a changing shade of existence," and as such even inside Memphis some slight changes have occurred. In three years of experimentations and experience the garish, funny, somewhat childish tones of the early days have been rounded off, harmonized, and classicized, just as the forms have become less ramshackle, less redundant, and simpler, with sharper, more self-assured, crystalline contours. Marble pieces (in colored, veined, baroque marble) have come into being, and after a while black also appeared – a plastic black with an imitation-marble finish, or a black gloss black, used as a dull mass along with shining aluminum, chrome, plate glass, and fireflake. The suburbs are making their way into the heart of the city.

Asked about the origins, motives, and goals of this silent metamorphosis, Sottsass sighs and says that you can't go on doing the same things all your life, then explains: "I've always looked for nonculturized color in the colors of children, and I've always drawn a blank because nobody understands this way of treating color. Nobody understood that the problem was to look for color in areas that no one had worked on. Anyway, that's the way it was. Now that we have been through that experience and got rid of our inhibitions, so to speak, we can do almost anything we want. We can even allow ourselves a more cultivated, more sophisticated color, because we know how to use it in a loose, detached way as though it had no links with any culture."

As always the basic idea in Memphis is to shake off the conditioned routine and recover fresh energy, to follow the logic of the moment, to look at things always from new points of view, and examine every new possibility. Light or dark, pale or saturated, bright or dull, Memphis color may be a matter of chance or necessity, of work or pleasure, never a problem.

Peter Shire, "Peninsula" table, Memphis 1982.
Metal and plate glass.

Peter Shire, "Bel Air" armchair, Memphis 1982.
Wood and woollen fabric.

The House of Wu Fong
"... Each one of the female inmates of Wu Fong's establishment had a tiny two-room suite for her own use, furnished and decorated in the style of the country from which she came. Thus, Marie, the French girl, had an apartment that was Directoire. Celeste's rooms (there were two French girls because of their traditional popularity) were Louis XIV; she being the fatter of the two..."
Nathaniel West, *A Cool Million*

Peter Shire, teapots, 1980-83. Produced by the designer.

Peter Shire, teapots, 1980-83. Produced by the designer.

Peter Shire, "Hollywood" table, Memphis 1983.
HPL Print laminate and metal.

Furnished by a Wealthy Madman

"... Bill pulled up one of the blinds, flooding the room with light. It was quite a large room, probably furnished by a very wealthy madman who hadn't skimped on valuable art objects. The skins of bears, lions, and other ferocious animals lay on the floor. At the center of the wall, opposite the door, stood a large brick fireplace over which hung a deer's head. On one side there was a sort of bookcase fitted with the latest in stereo equipment. There were sofas with no backs, and there were four of them, each different from the others... a fairly large oval table next to the entrance door... near the fireplace there was an open trapdoor. Bill went over and closed it.
 'There's nothing down here, it's just a hole to keep wine cool. But the fridge is over there,' he said, pointing to a piece of furniture that looked like a stereo console..."
Wallace Mackentzy, *Chosen for Hell*

Michele De Lucchi, "Lido" sofa, Memphis 1982.
HPL Print laminate, lacquered wood, metal
and woollen fabric.

Michele De Lucchi, drawings for a table, 1982.

Michele De Lucchi, drawings for a table, 1982.

Michele De Lucchi, "Fortune" table, Memphis 1982.
HPL Print laminate, lacquered wood and plate glass.

Michele De Lucchi, drawings for a table, 1983.

Michele De Lucchi, drawings for a sofa, 1982.

Gerard Taylor, "Airport" cabinet, Memphis 1982.
HPL Print laminate and metal.

Gerard Taylor, "Le Palme" bookcase, Memphis 1983.
HPL Print laminate, metal and glass.

10,15
"... Richard unlocked his room and stepped in. There was a police bar on the inside and he used it. There was a bed with almost white sheets and an army surplus blanket. There was a bureau from which the second drawer was missing. There was a picture of Jesus on one wall. There was a steel rod with two coathangers kitty-cornered in the right angle of the walls. There was nothing else but the window which looked out on blackness. It was 10,15..."
Richard Bachman, *The Running Man*

Gerard Taylor, "Glasgow" and "Piccadilly" lamps, Memphis 1982.
HPL Print laminate and metal.

Gerard Taylor, drawings for lamps, 1982.

Sottsass Associati, room with carpeting designed
by Nathalie du Pasquier for Louis De Poortere. "Savoy"
cabinet by George J. Sowden, Memphis 1983.

Sottsass Associati, room with carpeting designed
by Beppe Caturegli for Louis De Poortere.
"First" chair by Michele De Lucchi, Memphis 1983.

George J. Sowden, "Palace" chair, Memphis 1983.
Lacquered wood.

The Smoking-Room
"... 'An idea for the smoking-room? All right, here's one: Blue for the walls – a ferocious blue. The carpet purple – a carpet that plays second fiddle to the blue of the walls. Against that you needn't be afraid of using as much black as you like and a splash of gold in the furniture and ornaments.'
'Yes, you're right, Fred. But it will be rather drastic with all those strong colors. It's going to look rather charmless without a lighter note somewhere... a white vase or a statue.'
'Nonsense,' he interrupted rather sharply. 'The white vase you want will be me – me, stark naked. And we mustn't forget a cushion or some thingumabob in pumpkin-red for when I'm running about stark naked in the smoking-room!'..."
Colette, *Chéri*

THE MEMPHIS IDEA

A precise Memphis idea, in the sense of a manifesto, statute, or declaration of intent, doesn't exist. It doesn't exist because to spell things out has never seemed necessary; it doesn't exist because until now actions have seemed more important than words, the ideas, decisions, and points of view having surfaced, settled and taken shape through experience; it doesn't exist because the roots, thrust and acceleration of Memphis are eminently anti-ideological.

Memphis is anti-ideological because it seeks possibilities, not solutions. It is concerned above all with breaking ground, extending the field of action, broadening awareness, shaking things up, discussing conditions, and setting up fresh opportunities. This doesn't mean that the various designers, both individually and as a group, are without opinions, points of view, or stylistic propensities. The fact is that all decisions, initiatives, and inventions are treated as provisional – as tentative approaches or chance variants, not as certainties.

One might object that even this is an ideology, and maybe it is. But even so, it is an ideology whose outlines are deliberately blurred and flexible – a sort of superideology that one prefers to call an attitude. This attitude assimilates, or at least acknowledges, anthropological, sociological, and linguistic inquiry, from Lévi-Strauss to Barthes to Baudrillard; and it recognizes the impact of quantum and particle physics on the theories of knowledge.

Memphis does not propose utopias. It does not set itself up, as the radical avant-gardes did, in a critical position toward design; it does not practice design as an ideological metaphor to say or demonstrate something else. Rather, it proposes design as a vehicle for direct communication, and it attempts to improve the potential of its semantic dynamics as well as to update its contents. Memphis has abandoned the myths of progress and of a program of cultural regeneration capable of changing the world according to a rational design. Having also abandoned the utopias of the sixties and seventies, it has taken the first step toward the recomposition of an open and flexible design culture that is aware of history, conscious of consumption as a search for social identity and of the object as a sign through which a message is conveyed. This culture is actively engaged, as Branzi says, in the reconstruction of a system of expressive and emotional relations between man and the objects of his domestic habitat, reaching out from design to architecture and to the city.

Invitation to the third Memphis exhibition, 11 September 1983, Milan, Arc '74 Showroom.

Generally speaking the Memphis idea descends from Sottsass. Those who know him may discover many of Memphis's cultural roots simply by tracing Sottsass's career. While still quite young Sottsass learned that the "beauty," "formal correctness," "coherence," "function," even the "utility" of an object were not absolute, metaphysical values, but that they responded to a culture or a system, and varied in accordance with historical and cultural conditions.

So he began to look at architecture and design as sign systems, and to catalogue styles, colors, decorations, and formal tendencies statistically, in an attempt to understand what impact they could have or might have had in the context in which they arose, and why.

Sottsass's idea was not to arrive at the point of inventing a new style or a new formal program, but to discover how to use and apply this catalogue of signs in different circumstances and situations. Sottsass's uniqueness lies in the fact that his work never refers to an intellectual scheme, but to a sort of Morse code of sensory seductions transmitted to the body through physical messages (light, shadow, color, warmth, roundness, weight, thickness, fragility, etc.), rather than to the brain through cultural patterns. The basic suggestion that emerges from all of Sottsass's work is not dissimilar to an Indian sorcerer's advice to his disciple: to become a hunter and a warrior one must be fluid and unpredictable, distrust schemes and learn to disrupt systematically one's own routines.

Those who follow Sottsass pursue neither a style, nor an ideology. They adhere to a very simple principle; a principle which is really very ancient in the West as in the East: the world is perceived through the senses. Moving away from functionalism means taking one's distance from Cubism, the Bauhaus, Suprematism, Futurism, De Stijl – all movements that accepted the idea of an objective reality or "truth," and embraced a heroic and reformatory moral system in the pursuit of alibis and solutions of a spiritual, mental, logical, and ideological kind. "I am an idiot," says Sottsass, "and I've always said the problem is to eat, drink, sex, sleep, and stay down low, low, low. The world is an area of sensory recovery. I'm not talking about an image but about an attitude." And Sottsass goes on: "World culture today is concerned with the American vision of comfort. Today and for many hundreds of years to come humanity will pursue earthly comfort. Comfort means to possess warmth, coolness, softness, light, shade, air-travel, Polynesian spaces or Alaska. To have money means to possess sensory possibilities, not power. Sensoriality destroys ideology, it is anarchical, private; it takes account of consumerism and consumption, it is not moralistic, it opens up new avenues."

Out of this attitude comes an idea of design increasingly open to change and increasingly attentive and dedicated to the physical consumption of space, to material, tactile qualities, smells, sounds, colors, spatial tensions, air conditioning, and so on. Branzi says: "Today we know – and the experience of body art has confirmed our knowledge – that our perception of the environment is substantially a physical process carried out to a great extent by our body, which is not a brute receptacle of sensations and stimuli (on which only the 'intelligent' mind is able to impose order and meaning), but an active instrument capable of processing environmental data and of transforming them into experience and culture, utilizing them independently of their allegorical or ideological meaning."

Memphis originated from these intuitions and visions. Not from an aggressive, controversial outlook or a desire to invent new supports, monuments, truths or programs, but from a generic, biological, existential happiness; from the consciousness of life as an indifferent cosmic-historic event and from the desire to taste it, consume it, communicate it physically, almost chemically or molecularly, as a vibrant, neutral, enticing, seductive presence.

If the world is perceived through the senses, then

Nathalie du Pasquier, drawing for a metal object, 1982.

Nathalie du Pasquier, drawing for a metal object, 1982.

one can use the senses to communicate information of all kinds. One fundamental Memphis idea is to make design into a sophisticated, conscious instrument of communication.

As De Lucchi points out: "Design is an extraordinary tool for communicating because its intrinsic characteristic is the fact that it is used and distributed anyway, even without communicating anything. We are inventing the possibility of communicating through objects. We are trying to connect design and industry to the broader culture within which we move."

When a Memphis designer makes a design he or she does not merely define a product that must contain, pour, light, support, hold, or rest. He or she thinks, visualizes, and formally engineers the design as a set of expressive signs with certain cultural contents. Communicating through design means thinking of design as a semantic event, charging an object with information, making it a metaphor, designing it as an active presence rather than a dull, opaque support for functions. In the end it also means redefining the concept of function, which is what the Memphis designers are doing.

Branzi says: "All industrial design, as part of the Modern Movement, and all design ideology, is based on the certainty that the basic quality of an environment or of an object consists in its structural correctness; that is, in the balanced harmony between form, structure, and functional necessities, from which both its linguistic expressiveness and its social value derive in a direct and almost mechanical way. This certainty has distant origins – in the Renaissance, in Christian morality, and in the spirit of the industrial revolution."

This certainty generated, among other things, the weak and schematic catch-phrase, "form follows function," and for several decades everything seemed clear and simple. It all boiled down to defining the function, and giving it a form – without considering that function is a highly complex variable that relates to cultural conditions, to public imagination and necessity, to the thrust of historical events. As Sottsass said in an interview, "As we know very well, when you try to define the function of any object, the function slips through your fingers, because function is life itself. Function is not one screw more or one measure less. Function is the final possibility of the relation between an object and life."

In order to redefine the concept of function one must rescue it first of all from the schematism of ergonomic interpretations, and recognize its ambivalence, variability, and complexity. Ergonomic theories, often invoked as definitive arguments or propagandized as advertising slogans, are support technologies of the design, and are likewise variable. But faced with a dining-room chair, no ergonomic or specific marketing theory on this planet can ever guarantee or even explain why one "likes" the chair (and why it sells), why it is "comfortable" for some but not for others, and what its "comfort" really consists of. Thus functions do not always exist or lend themselves to ready analysis. Architects and designers often invent them, viewing design as an active instrument of behavior modification. "They create demand itself," says Branzi, "that is, new functions and new freedoms."

As early as 1954 Sottsass wrote: "When Charles Eames designs his chair, he does not design just a chair. He designs a way of sitting down. In other words, he designs a function, not for a function." Memphis tries to look at function with open eyes and ears, more like an anthropologist or a sociologist than an engineer or a marketing man. Memphis says that, subject to current ergonomical rules and to a few simple and almost invariably schematic functional necessities, an object exists as a system of signs, as a catalyst of emotions, as a representation of a cultural state, as a container of values or information that one wants to possess, as an active presence, a reassuring wink – in other words, as an instrument of communication.

Gertrude Stein: "I don't consider an artist creative if not as a contemporary."

Nathalie du Pasquier, drawings
for metal objects, 1982.

Nathalie du Pasquier, drawings for metal objects, 1983.

Otto Wagner: "The only possible starting point for our creativity can be modern life."

It remains to be explained what metaphors and information Memphis conveys, where it gets its repertory of signs and what iconography it proposes. We've already talked about materials, plastic laminates, decoration, color, and the fact that the Memphis iconographic package is concerned with contemporaneity. In this sense Memphis is decidedly different from the Postmodernist mainstream, which is historicist and inclined toward restoration in that it looks backward to classical or vernacular architectural culture. Memphis's efforts and interest are concentrated instead on the present and on that special part of the present which is the hot-house of the future. Memphis, it is important to repeat, has drawn its imagery from areas of germinal culture, of the "speaking mass," where language is in continuous evolution – areas of underdevelopment, suburbs, no-man's-lands, the "frontier" of megacities. In its attempt to move modernity ahead (the first such attempt since the Bauhaus), Memphis has looked to the East as well as the West.

Spreading its reference points as widely as possible, it has tried to capture planetary anxieties, and has attempted to perceive, absorb, and refract the shudders and tensions of growth of the third world. When quoting suburbia it also had in mind the suburbs of Bombay, Madras, Merida, Jeddha, Sana'a, Jakarta, Wonosobo and Taroudant. It had in mind, that is, all the third-world architecture of new settlements from Polynesia to Java, from India to the Middle East, from Africa to South America – where the native taste for decoration and color is grafted on to an imported rationalism reinterpreted in a pop key.

In these areas, where "language" is bubbling and not yet codified, signs are born and recycled according to the ambivalent logic of desire. Language's utopian function grows out of the bittersweet shock of this happy state of indetermination and ambiguity, acting like a whiplash on the faded, tired layers of worn-out gestures and messages. It is always a disturbing, insubordinate, perverse, and hence joyous function. When Memphis was born, it was perfectly crisp, fresh, and vibrant with joy inside this almost childlike state of naïvité and impudence, and it met with widespread enthusiasm because it represented a liberation from the puritan asceticism of institutional culture, it turned people's stomachs for the sheer pleasure of doing and saying so, thus throwing the doors open on an immense range of expressive possibilities.

Many have considered the introduction of certain signs, materials, decorations, and linguistic and formal discontinuities a game, a snobbish pastime, an exhibitionistic and vulgar joke. It would have been too costly a joke. Perhaps Memphis's greatest merit is the enormous wealth of new energy it has thrown on the scales opposite the tired but heavy values of official design, tradition, and history – an enormous weight which would be hard even to imagine moving. And yet, contrary to all expectations, the earlier balance seems to have altered. Consumerism, besides being a necessity induced by the production system, is also a pleasure; and a pleasure is never completely controllable or without consequences. Putting new signs on the air means circulating new energies, producing new desires, anxieties, incentives, and conditions. The consumer mechanism is a very special woodworm that corrodes the system from within while regenerating it continuously. It is also a double-edged woodworm: it eats and regenerates and in giving birth it produces mutations. The mutations represent the percentage of risk in the survival system.

Memphis is one of the mutations. It is born of the age of data processing, within the system, not against it. It utilizes the most advanced structures and strategies, it grows and spreads by working directly on the connective tissue of the environment, working on the senses, on details, on microstructures, on speed. Its products are chips of extraordinarily high expressive density, unstable genetic hybrids that strike the planet like a new wind, bearers of new barbarities perhaps, or of another civilization.

Ettore Sottsass, "Carlton," Memphis 1981.
HPL Print laminate.

My Idea
"... 'My idea' – said Keawe – 'is to have a beautiful house and garden on the Kona Coast, where I was born, the sun shining in at the door, flowers in the garden, glass in the windows, pictures on the walls, and toys and fine carpets on the tables, for all the world like the house I was in this day – only a storey higher, and with balconies al about like the king's palace; and to live there without care and make merry with my friends and relatives'..."
Robert Louis Stevenson, *The Bottle Imp*

Ettore Sottsass, "Metro," Memphis 1983. HPL Print
laminate, metal and marble.

The "Processed Leather Room"
"... The meeting took place in what I called the 'processed leather room' – it was one of six done for us by a decorator from Sloane's years ago, and the term stuck in my head. It was *the* most decorator's room: an angora wool carpet the color of dawn, the most delicate gray imaginable – you could hardly walk on it; and the silver panelling and leather tables and creamy pictures and slim fragilities looked so easy to stain that we could not breathe hard in there, though it was wonderful to look into from the door when the windows were open and the curtains whimpered querulously against the breeze..."
Francis Scott Fitzgerald, *The Last Tycoon*

Sottsass Associati (Ettore Sottsass, Marco Zanini),
Entrance Hall in Cedit tiles, The Milan Style collection, 1983.
Tiles by George J. Sowden and Rudi Haberl.

148

Sottsass Associati (Ettore Sottsass, Marco Zanini), room design
for the Italian Design Exhibition in Tokyo, February 1984. HPL Print
laminates, Artemide lamp, Cedit tiles, The Milan Style collection.

Nathalie du Pasquier, architecture, 1982.

Martine Bedin, "Prince" table, Memphis 1983. Marble.
Produced by Up & Up, Massa.

Martine Bedin, drawing for a table, 1983.

Shiro Kuramata, "Kyoto" table, Memphis 1983. Terrazzo.

Marco Zanini, "Rigel," Memphis 1982. Blown glass.
Produced by Toso Vetri d'Arte, Murano.

Marco Zanini, "Arturo" and "Vega" glasses, Memphis 1982. Blown glass. Produced by Toso Vetri d'Arte, Murano.

Crystal

"... All around the servants moved with large, gold stripes. The big candlesticks like bouquets of fire blossomed on the wallpaper, and the mirrors repeated them. At the end of the dining room with its trellis of jasmine stood the sideboard, which resembled a high altar or a jeweler's window, so numerous were the plates, glasses, cutlery, the silver and gilded-silver spoons amid the facets of the crystal doors that sent iridescent glares over the food. The other three rooms were brimming with artistic objects. Frederick heard here and there phrases like this: 'Who composed this polka?' 'My goodness, I'm sure I don't know, madam...'"

Gustave Flaubert, *L'Education Sentimentale*

Ettore Sottsass, drawing for a glass vase, 1983.

Ettore Sottsass, "Sol" fruit dish, Memphis 1982. Blown glass.
Produced by Toso Vetri d'Arte, Murano.

Ettore Sottsass, "Alioth" and "Alcor" vases,
Memphis 1983. Blown glass. Produced
by Toso Vetri d'Arte, Murano.

In Spite of These Things
"... But, in spite of these things, it was a gay and magnificent revel. The tastes of the duke were peculiar. He had a fine eye for colors and effects. He disregarded the *decora* of mere fashion. His plans were bold and fiery, and his conceptions glowed with barbaric lustre. There are some who would have thought him mad. His followers felt that he was not. It was necessary to hear and see and touch him to be *sure* that he was not..."
Edgar Allan Poe, *The Mask of the Red Death*

Ettore Sottsass, "Sirio" vase, Memphis 1982. Blown glass.
Produced by Toso Vetri d'Arte, Murano.

Michele De Lucchi, "Antares," Memphis 1983. Blown glass.
Produced by Toso Vetri d'Arte, Murano.

Matteo Thun, "Cuculus Canorus," 1982. Ceramics.
Produced by Alessio Sarri, Sesto Fiorentino.

A Weird Place

"... Irritably she rose and began to pace the confines of the tent. It was a weird place hung with dried bones, gourds, various leaves and assorted spears and bows. A modern laser gun rested on a bracket. A curtain hung before a bed. Stainless metal traveling cases stood beside plastic boxes on the floor which was covered by a mess of skins. A doctor box supported an everlasting lamp. A dreamlight glowed with ever-changing color. A tall cabinet of woven reeds held clothing. 'You're a damned nuisance' – she said – 'a prying nurd'..."

E.C. Tubb, *Stellar Assignment*

Matteo Thun, drawings for coffee pot,
teapot and milk-jug, 1981.

Matteo Thun, drawings for a fruit dish and teapot, 1981.

Matteo Thun, "Columbina Gratiosa" and
"Corvus Corax," 1982. Ceramics. Produced
by Alessio Sarri, Sesto Fiorentino.

Matteo Thun, "Columbina Superba" and
"Columbina Spheroidea," 1982. Ceramics. Produced
by Alessio Sarri, Sesto Fiorentino.

Matteo Thun, "Passerina Noctua" and
"Larus Realis," 1982. Ceramics. Produced
by Alessio Sarri, Sesto Fiorentino.

Matteo Thun, "Pelicanus Trivialis" and
"Larus Marinus," 1982. Ceramics. Produced
by Alessio Sarri, Sesto Fiorentino.

Matteo Thun, "Pelicanus Bellicosus," 1982.
Ceramics. Produced
by Alessio Sarri, Sesto Fiorentino.

Masanori Umeda, "Parana" fruit dish,
Memphis 1983. Ceramics.
Produced by Ceramiche Flavia, Montelupo Fiorentino.

Marco Zanini, drawings for ceramics, 1982.

Marco Zanini, "Colorado" and "Mississippi"
teapots, Memphis 1983. Ceramics.
Produced by Ceramiche Flavia, Montelupo Fiorentino.

Marco Zanini, "Victoria," "Baykal," and
"Tanganyka" vases, Memphis 1983. Ceramics.
Produced by Ceramiche Flavia, Montelupo Fiorentino.

Memphis meeting at Laglio, Como, October 1982. From the upper left: Nathalie du Pasquier, Martine Bedin, Matteo Thun, Cristoph Radl, Barbara Radice, Gerard Taylor, Aldo Cibic, Ettore Sottsass, Ernesto Gismondi, Egidio Di Rosa, George J. Sowden, Michele De Lucchi, Marco Zanini.

THE DESIGN

Sottsass: "To me, doing design doesn't mean giving form to a more or less stupid product for a more or less sophisticated industry. Design for me is a way of discussing life, sociality, politics, food, and even design."

The Memphis attitude naturally affects even the traditional approach to the design. Memphis says that the design is never the "solution" to a problem, because no problem is ever a motionless event that can be isolated and grasped, but a changeable, versatile event continually revolving in the midst of other problems also in motion.
A design is the relation with a series of problems and their intercourse, a relation that cannot be made systematic because it obeys the logic of circumstance.
In keeping with this attitude and with the idea that there are no objective realities but only cultural forms and perceptions, Memphis designers started not to build objects around a structure, but to tear them open, so to speak – to explode them, to disintegrate them in order to read and manipulate them as sign systems.
Memphis design is permissive: it expresses "intermediate states," or sets of relations, instead of structured thoughts; it is not based on how we "think" of things, but on how we "experiment" them. It does not describe, imitate, or seek to explain experience, but "alludes" to experience, it speaks in the language of myth rather than in that of logos. It endeavors not to convince, but to seduce.
As I said about decoration, the switch from the traditional way of designing is like a leap from the static categories of the macrocosm to the virtual universe of particles where there are no certainties, just probabilities; no realities, just experiences; where what is = what happens.
A piece of Memphis furniture is a linguistically controlled assembly whose final form is not the result of a design story held together by constructive coherence, but a milk shake of possibilities, an accident that represents the variable and unstable logic of the parts that compose it: volumes broken into different kinds of surfaces, surfaces fragmented by decoration and diversified by textures, materials, color.
This dimensional leap, which causes an object to be perceived as a swarming assembly of molecules more than as a body in itself; this kind of pulverization of form, structure, surfaces, volumes, and coherence of design, in addition to making the information easier to assimilate, helps to avoid getting bogged down in a style.
Memphis, born in an age of consumer society, is attracted rather than repelled by it, and while offering itself up for consumption it keeps trying to update its iconography. Once it has spotted a figurative possibility it doesn't pause to possess, observe, investigate, or codify it; it doesn't try to define its contours, corollaries, or variants. It consumes it right away, abandons it to its destiny and goes on to something else.
De Lucchi: "Perhaps because we feel that following a certain path would lead us to things we're not interested in, for instance to a stylistic coordination that we're not looking for."

"The Memphis style," says Sowden, "consists of broadening the area of style itself, of never being satisfied with what has already been done, and of looking for a new style all the time."
It is faith in a permanent creative restlessness.
The idea of a perennially accelerated consumption, of mobility, and commutability of style, and of the possibility of a continuous updating and diversification of image and of language, involves a basic change in managerial attitudes and traditional industrial logic. This phenomenon is in concert with the advent of postindustrial culture, which is no longer monolithic, monocentric, monotonous, but polyvalent, sectorial, decentralized, "transistorized." In other words, it requires an updating of industry based on the culture it helped create.
Branzi says: "Traditionally, industrial design aims at identifying standard objects and products that represent a neutral section of the mass market – objects that everybody can use. But in present society, which theoreticians call postindustrial, the great mass markets have disappeared. They have been replaced by a polycentric market, that is, by different sectorial markets organized around cultural groups with different languages, traditions, and behavior. New Design aims at identifying products that are not for everyone, but on the contrary are capable of choosing their own users; the target is a specific culture, and the products therefore have strong cultural connotations."
From the very start, Memphis tried to establish a special relationship with industry, forcing it to play, perhaps for the first time in its history, a different role. Instead of continuing to pursue a kind of entropic fixation of images, instead of forcing images to adhere like a tight skin to its acid logic, industry, under the designers' impetus, has tried to adjust to the idea of variety and opulence and has come to accept the "functional" not only in terms of meeting production quotas, obsessively reducing costs, launching global mass distribution plans, and finding integral and definitive existential solutions to its problems, but also in terms of imaginative quantity, metaphoric charge, linguistic sophistication.
Memphis's relationship with industry is a colossal novelty from the point of view of management, sales, and production, as well as from that of design. And inevitably in this connection it has been misunderstood.
From the very beginning Memphis was culturally conceived in industrial terms. It started as a movement of Milanese architects and designers who wanted to take up the challenge of and to work with production and industry, using the latest, most sophisticated means of distribution and sales, acknowledging industry's important role as catalyst and promoter of public culture and pleasure, and reserving the possibility to alter, where possible, some of its rigidities and schemes. For this reason, too, Memphis grew out of Alchymia which structurally had represented an embryonic, "artistic," private stage of research.
Memphis, with the fixed idea of the design-message-sign, has never even contemplated the problem of

furniture as a one-of-a-kind object or work of art (and despite requests it has always refused to produce limited editions).

Nor has Memphis made concessions to the nostalgia for Arcadia, populism, or the "Golden Age," or for crafts as a means of social purification and reconstruction. It has presented itself on the market as merchandise, and it has always used all possible and available circuits for distribution. It has exhibited in museums and art galleries, but also in showrooms and department stores, in boutiques and suburban garages. Its designs have wound up in books on the history of industrial design, but also on TV commercials. All Memphis pieces, except for the blown glass, are designed for industrial production. If they are produced in small series it is only because the demand is limited.

And yet, with all this, and for two different reasons (both wrong), some have spoken of Memphis as an arts-and-crafts revival, as an alternative to industrial production, firing a widespread, ridiculous misunderstanding, in spite of the numerous written and verbal statements in which this question is thoroughly and clearly dealt with (such as Branzi, *Merce e Metropoli*, Edizioni EPOS, published by the Faculty of Architecture of Palermo University).

The fact is that, whichever way you look at it, the problem of the craft/industry alternative as a system of production today no longer exists. With the birth of industry the world of crafts split in two, like a ripe melon. On the one hand so-called handicraft has survived as the depository of certain traditional values – hand-made, one-of-a-kind articles – more and more estranged from innovation, eventually becoming an alienated system of reproduction of preestablished formal or historical models that the market already offers. On the other hand, craft skills have developed as a specialized stage of industrial design, as an experimental area open to new models that mass production cannot deal with because of its rigid technical and productive structure, and as a specialized phase of a very advanced and sophisticated type of production. Suffice it to think of space capsules, the Shuttle, and Space Lab, which are built "by hand" in a very limited number, not as "prototypes" but as ready-to-use "products."

Memphis has never even dreamed of opting for one path or the other.

Branzi: "Memphis utilizes the building technology of both industry and craft (the difference is irrelevant) with the aim of sparking new experiences capable of renewing language." And that's all.

In other words Memphis makes use of the most agile and flexible structures available on the market.

Perhaps in the future computerized processes will give industry an ever greater agility. Perhaps, as is already the case in other fields, production lines will present different options, and it will be possible to vary and diversify products even more rapidly.

As Arata Isozaki says: "We will just have to try to survive until that day."

Ettore Sottsass, "City" table, Memphis 1983.
HPL Print laminate and metal.

Michele De Lucchi, "First" chair, Memphis 1983.
Metal and lacquered wood.

Ettore Sottsass, drawing for a coffee-table, 1983.

A Carafe of Russian Vodka

"... It was... an unusual octagonal room with cinnamon lacquered walls, a yellow lacquered floor, brass bookshelves (a notion borrowed from Billy Baldwin), two huge bushes of brown orchids esconced in yellow Chinese vases, a Marino Marini horse standing in a corner, a South Seas Gauguin over the mantel, and a delicate fire fluttering in the fireplace. French windows offered a view of a darkened garden, drifting snow, and lighted tugboats floating like lanterns on the East River. A voluptuous couch, upholstered in mocha velvet, faced the fireplace, and in front of it, on a table lacquered the yellow of the floor, rested an ice-filled silver bucket; embedded in the bucket was a carafe brimming with pepper-flavored red Russian vodka..."

Truman Capote, *Mojave*

Ettore Sottsass, "Park Lane" table, Memphis 1983. Fiberglass and marble. Produced by Up & Up, Massa.

Nathalie du Pasquier, building, 1982.

The Labyrinth

"... They decided to leave a common memorial of their reigns, and for this purpose constructed a labyrinth a little above Lake Moeris, near the place called the City of Crocodiles. I have seen this building, and it is beyond my power to describe; it must have cost more in labour and money than all the walls and public works of the Greeks put together – though no one would deny that the temples at Ephesus and Samos are remarkable buildings. The pyramids, too, are astonishing structures, each one of them equal to many of the most ambitious works of Greece; but the labyrinth surpasses them. It has twelve covered courts – six in a row facing north, six south – the gates of the one range exactly fronting the gates of the other, with a continuous wall round the outside of the whole. Inside, the building is of two storeys and contains three thousand rooms, of which half are underground, and the other half directly above them. I was taken through the rooms in the upper storey, so what I shall say of them is from my own observation, but the underground ones I can speak of only from report, because the Egyptians in charge refused to let me see them, as they contain the tombs of the kings who built the labyrinth, and also the tombs of the sacred crocodiles..."

Herodotus, *The Histories*

Nathalie du Pasquier, city, 1983.

Nathalie du Pasquier, detail of the city, 1983.

Nathalie du Pasquier, detail of the city, 1983.

Aldo Cibic, house, 1983.

Martine Bedin, building, 1981.

Martine Bedin, building, 1981.

MEMPHIS AND FASHION

Memphis was started with the idea of changing the face of international design, and it chose the most effective, direct, and hazardous way to do so. It showed that the change not only was possible, but had already taken place, that it involved worldwide aspirations and personalities and that it was a radical one. Born in an anomalous way, outside of academic culture, Memphis also made its début in a flashy way. It came up with a large number of products presented to the beat of good rock music and with a way-out type of display and allure. The idea was to attract attention, and the response was immediate. The opening was followed by a tidal wave of interest among the public and the press. The resulting gossip and arguments, the passionate or amused support, the harsh, drastic criticism, the interviews, the publicity – all this very quickly made Memphis not only a successful cultural movement, but a myth, a sort of liberating symbol with which many people wished to identify. To put it in the words of a twelve-year-old American girl who wrote to ask for a piece of furniture for her bedroom, Memphis was already "like a rock star." This overnight stardom momentarily embittered those who, in spite of themselves, had been caught up in the whys and wherefores of that success. Nevertheless it ended up representing, for those same people, the response to many embarrassing doubts and questions. It showed, in other words, that Memphis was "a fad," "just" a fad. With a little bitterness, then, one could catch one's breath.

Quite differently, with a mixture of joy and anxious astonishment, the people on the other side of the moon caught their breath too. Memphis architects and designers and their friends and supporters saw the fact of being a fad, of moving "à la mode" and "comme la mode," as a sign of great vitality.

Arata Isozaki pointed out: "The important thing about Memphis is also the way it appeared to the world. Normally a furniture manufacturer announces a product, prints a catalogue, and so on and so forth. Memphis appeared suddenly, as fashion does, and it had a very strong impact all over the world... things always change rapidly anyhow. At the Bauhaus, the tubular chairs were designed between 1920 and 1925, no earlier and no later. The designers of those chairs changed style later, but the objects lived on. They are still produced even today."

Memphis never feared fashion, being a fashion, or going out of fashion. On the contrary it foresaw and adjusted from the outset to this fluid state of variability. I quote from my introduction to the catalogue, the statement that perhaps caused the greatest uproar at the time of the presentation in 1981:

Postcard of Memphis, Tennessee, reproduced on the back of Memphis envelopes.

"We are all sure that Memphis furniture will soon go out of style."

The whole Memphis idea is oriented toward a sensory concentration based on instability, on provisional representation of provisional states and of events and signs that fade, blur, fog up and are consumed. "It is no coincidence," says Sottsass, "that the people who work for Memphis don't pursue a metaphysical aesthetic idea or an absolute of any kind, much less eternity. Today everything one does is consumed. It is dedicated to life, not to eternity."

Memphis works for contemporary culture, it designs for consumption. When Memphis designers say they design "for communication" they cast off the alibis of useful, "clean," lasting design, design that solves functional (or social...?) problems. Their brand of communication consists in presenting an object that is attractive by virtue of its elusive, evanescent, consumable, perversely "useless" and consequently infinitely desirable qualities. Communication – true communication – is not simply the transmission of information (which in the case of a "product" is always unilateral, from the product to the consumer). Communication always calls for an exchange of fluids and tensions, for a provocation, and a challenge. Memphis does not claim to know what people "need," but it runs the risk of guessing what people "want." With the same words Ruthie (in the song, "Stuck Inside of Mobile with the Memphis Blues Again," which gave Memphis its name) answers Bob Dylan, who discourages her advances under the Panama moon, protesting his fidelity to a debutante. Ruthie says: "Oh but your debutante just knows what you need, but I know what you want." The two things often don't coincide at all.

Memphis doesn't give away or solve anything. Memphis, as I said before, seduces. It seduces by virtue of its enigmatic and contradictory qualities. It seduces because the void of values that it has created by refusing to solve problems, to be logical, definitive, positive, stable, or lasting represents a challenge to common sense-good taste-respectability. It seduces because it is impassive in happily declaring that it is meant to be consumed.

Naturally there's a trick, and the trick is part of the challenge. Memphis has unabashedly, almost obscenely stripped-off the aura of usefulness and the more arcane aura of art (which many of its enemies shrewdly continued to attribute to it). It has gambled all its charm on this emptying of meaning, and with this turn of the screw has won the "fatal" powers of the absolute object, of which Baudrillard speaks: "An absolute object is an object whose value is null and whose quality is indifferent but which escapes objective alienation because it becomes more an object than the object, and this gives it a fatal quality."[1]

The fatal quality mentioned by Baudrillard is the quality an object acquires when it becomes a fetish, and it ceases to show its use-value, when it relinquishes the "risible claim of assigning to every event a cause and a cause to every event," and declares that only "effects" are absolutely necessary.

This is also the secret quality of fashion. A quality transgressive of all value judgements and codes, for it is tied to the arbitrary charm of the ephemeral. A quality that eludes, *because* it is ephemeral, the solidity and viscosity of feeling and of history, that is, it eludes duration (eternity) and pledges itself to extinction (to life).

Memphis objects, like fashion, are purely tautological, they are "immoral."

As I attended Memphis openings in London, Los Angeles, Milan, Tokyo, San Francisco, and New York, I often wondered about the strange power of these objects – a power extending over an extremely heterogeneous public, a power capable of transforming a furniture show into an ecstatic event, a momentary collective trance, a sort of esoteric initiation that marks the passage into a special cultural caste.

Memphis, I told myself, is not just a cultural event, it is an erotic event, an erotic-consumer rite that absorbs anxieties and recycles energies; it is a lubricating essence, a fine tuning of metabolism, a focusing of perspectives. At least this is the kind of effect it has – even on nonspecialists, even on the skeptics who reject it but feel it, and above all on young people.

Memphis, like the fruit of the tree of knowledge, contains a promise and a challenge inextricably bound up with, and metamorphosed into one an-

Michele De Lucchi, drawings for "Hypotheses for an office space," Olivetti-Synthesis exhibition at the Triennale di Milano, 1983.

other. The trick I mentioned earlier is that Memphis objects, by emptying themselves of meaning and charging themselves with enigma, go back to being ritual objects, propitiatory diagrams, ceremonial formulas. They offer life, not an explanation but a sense, arbitrary as it may be; the sense of life in self-contemplation.

Memphis, like fashion, works on the fabric of contemporaneity, and contemporaneity means computers, electronics, videogames, science-fiction comics, Blade Runner, Space Shuttle, biogenetics, laser bombs, a new awareness of the body, exotic diets and banquets, mass exercise and tourism. Mobility is perhaps the most macroscopic novelty of this culture. Not only physical mobility but also and above all mobility of hierarchies and values; and mobility of interpretations which has liquefied the contours and solidity of things, shrinking the long, lazy waves of our "Weltanshauung" to increasingly high frequencies until they burst and evaporate in a dust of hypotheses, in a whirl of events. What matters to us is not their substance but their appearance, their virtual image. It is the world of TV screens, the world of shadow, where, as in Zen stories, it is never clear whether you dream you are a butterfly or the butterfly dreams it is you.

Memphis has plunged into the flow of this mobility and acts as a reflector, as a radar, as a talisman capable of harmonizing with the subtle ripples of this perennial, accelerated metamorphosis. At least it tries to.

At Memphis they say that even a design must "happen" in real time. It must move, in other words, in the fluid logic of variability and produce objects destined for total and immediate consumption, objects as intense as apparitions, as magic as curses, concentrates of existential lust. Objects whose charisma, whose "secret name," should be outlined by the concentration, compactness and speed of the energies they are able to contain and unleash rather than diluted in the boredom of an aphonic, and equally arbitrary design, of stability, solidity, and duration. Memphis quality is of no interest, nor can it be known how long it will "last." One might say that it is a quality concerned with the exact opposite of "duration," with self-destruction, annihilation, disappearance, which is also the magic formula of our destiny, of life which in order to glitter must fade and liberate, as radioactive fall out, the shivers and omens of the end.

(1) Jean Baudrillard, *Stratégies Fatales* (pub. by Bernard Grasset): "This doubly revolutionary movement (doubly revolutionary because it responds to alienation *on its own terms*, following the inexorable paths of indifference) are prefigured in Baudelaire's idea of absolute commodity... If the 'commodity' form destroys the former ideal aura of the object (its beauty, its authenticity, and even its functionality), then one must not attempt to revive it by denying the formal essence of commodities. On the contrary – and herein lies all the strategy of modernity that represents for Baudelaire the perverse and adventurous seduction of the modern world – one must push this division of value to its absolute limit. There must be no dialectic between the two parts: the synthesis is a weak solution, and the dialectic is a nostalgic one. The only radical and modern solution is to strengthen what is new, original, and unexpected, what is really special in the concept of commodity, namely, the formal indifference to utility and value, the preeminence given to circulation without reserve. Hence works of art must take on all the characteristic of shock, strangeness and surprise; of uneasiness, liquidity, self-destruction, instantaneity, and unreality that belong to commodities. They must emphasize the inhumanity of exchange value in a kind of ecstatic enjoyment and irony of the indifferent ways of alienation. Hence in the *fabulous*-ironic (and not dialectic) logic of Baudelaire, works of art are totally identified with fashion, advertising, and 'the *fabulous* character of the code.' They are resplendent with venality, mobility, irreferential effects, risks, and vertigo-pure objects of a wonderful commutability, because once the causes disappear, all effects are virtually equivalent. They can also be null, we know well, but it is up to the work of art to make a fetish of this nullity, this disappearance, and to obtain extraordinary effects from it... Vulgar commodities generate only the universe of production – and God knows if this universe is melancholy. Raised to the power of absolute commodities, they produce effects of seduction."

Michele De Lucchi, drawings for "Hypotheses for an office space," Olivetti-Synthesis exhibition at the Triennale di Milano, 1983.

Ettore Sottsass, Michele De Lucchi, "Hypotheses for an office space," Olivetti-Synthesis exhibition at the Triennale di Milano, October 1983.

Ettore Sottsass, Michele De Lucchi, "Hypotheses for an office space," Olivetti-Synthesis exhibition at the Triennale di Milano, October 1983. Exterior of a meeting room and of an executive's office.

Michele De Lucchi, vacation home realized
for Enichem, in the exhibition, "Houses of the Triennale,"
Triennale di Milano 1983.

Matteo Thun, building, 1983.

George J. Sowden, building, 1983.

Michele De Lucchi, studies of a house, 1982.

Michele De Lucchi, skyscrapers, 1983.

Michele De Lucchi, skyscrapers, 1983.

Michele De Lucchi, skyscraper, 1983.

Michele De Lucchi, skyscraper, 1983.

Ettore Sottsass, buildings, 1982.

Ettore Sottsass, design for a building, 1983.

Ettore Sottsass, design for a photography
studio with house, 1983.

Ettore Sottsass, design for a skyscraper in Dallas, 1983.

Ettore Sottsass, design for a Museum of Applied Arts,
for Max Palevsky, 1983.

George J. Sowden, city, 1983.

List of photographers

Studio Azzurro	27, 28, 31, 32, 33, 34, 35, 36, 40, 48, 58 (down), 59, 60, 70, 74, 77, 80, 90, 91, 93, 94, 95, 96 (down), 97, 100, 102, 103, 106, 107, 108, 109, 110, 112, 113, 114, 115, 116, 117, 119, 120, 122, 123, 126, 127, 129, 132, 133, 134, 140, 141, 146, 147, 152, 154, 155, 157, 158, 159, 160, 168 (down), 170, 171, 174, 175, 177, 188, 189, 190
Aldo Ballo	37, 41, 49, 66, 68, 69, 75, 86, 88, 96 (up), 101, 104, 136, 137, 138, 139, 145
Marirosa Ballo	148, 149
Santi Caleca	16
Roberto Carra	10, 154
Guido Cegani	172
Centrokappa	23
Mitumasa Fujituka	153
Jan Jacobi	161, 168 (up)
Giorgio Molinari	22
Occhio Magico	13, 17, 18, 19, 24, 25
Peter Ogilvie	58 (up), 76, 79, 105, 121
Pino Prina	15
Jacques Schumacher	72, 73 (copyright Mode & Wohnen)
Pino Varchetta	26
Fabio Zonta	164, 165, 166, 167

List of illustrations

Martine Bedin	8, 35, 102, 103, 104, 152, 183, 184
Andrea Branzi	16, 17, 18, 19, 23, 46, 47, 60, 61, 68, 115
Beppe Caturegli	138, 139
Aldo Cibic	100, 102, 182
Michele De Lucchi	20, 21, 22, 29, 30, 36, 41, 70, 71, 74, 76, 84, 85, 98, 99, 127, 128, 129, 130, 131, 160, 175, 186, 187, 188, 189, 190, 193, 194, 195, 196, 197
Nathalie du Pasquier	31, 42, 43, 44, 45, 87, 90, 92, 93, 94, 114, 136, 137, 142, 143, 144, 150, 151, 178, 179, 180, 181
Michael Graves	48, 49, 50, 51, 52, 53, 54
Valentina Grego	82
Rudi Haberl	34, 147
Hans Hollein	59
Arata Isozaki	121
Shiro Kuramata	66, 101, 153
Xavier Mariscal	58
Alessandro Mendini	24, 25
Paola Navone	25
Michael Podgorschek	33
Daniela Puppa	114
Christoph Radl	28, 82
Peter Shire	55, 56, 57, 58, 120, 122, 123, 124, 125, 126
Ettore Sottsass	7, 12, 13, 14, 15, 23, 27, 32, 33, 34, 37, 62, 63, 77, 78, 79, 96, 97, 105, 112, 113, 116, 117, 118, 119, 138, 145, 146, 147, 148, 149, 156, 157, 158, 159, 174, 176, 177, 188, 189, 198, 199, 200, 201, 202, 203
George Sowden	31, 38, 39, 40, 64, 65, 69, 75, 76, 89, 95, 140, 147, 192, 193, 204, 205
Gerard Taylor	132, 133, 134, 135
Matteo Thun	88, 106, 107, 108, 109, 110, 111, 114, 161, 162, 163, 164, 165, 166, 167, 168, 191
Masanori Umeda	80, 81, 168
Marco Zanini	10, 68, 91, 147, 148, 149, 154, 155, 169, 170, 171

Memphis meeting at Asolo, December 1983.